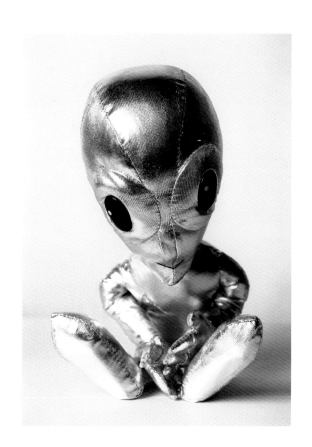

TUNICHTGUT

Frank Darius

KRUSE

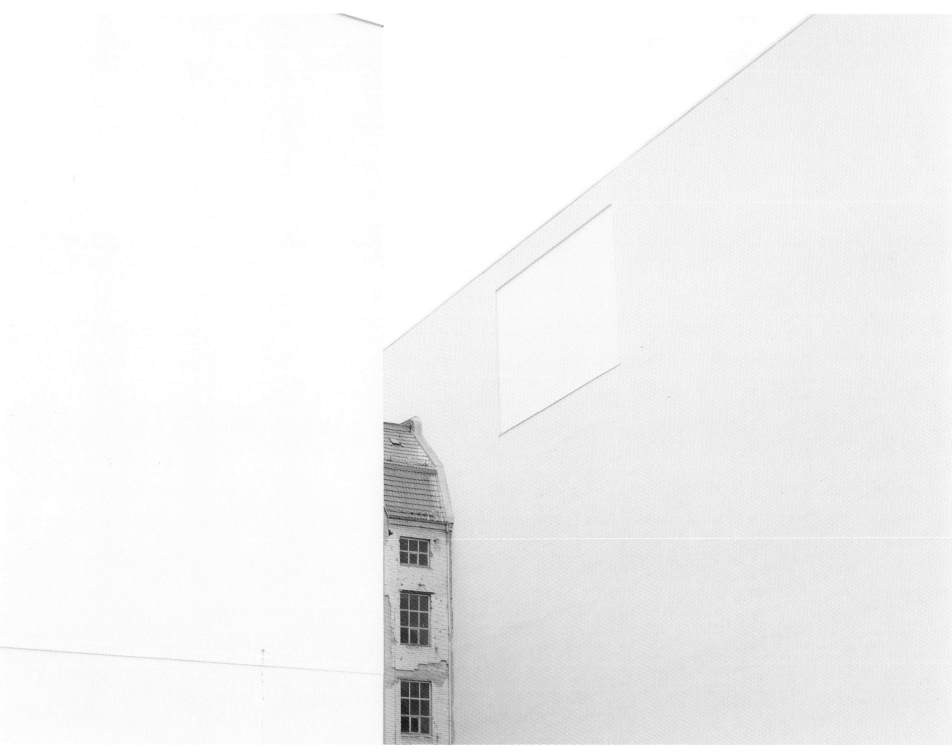

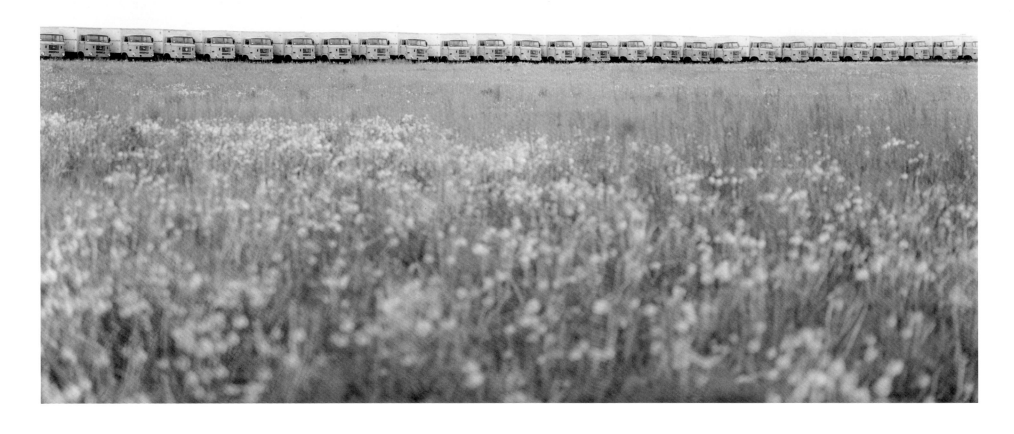

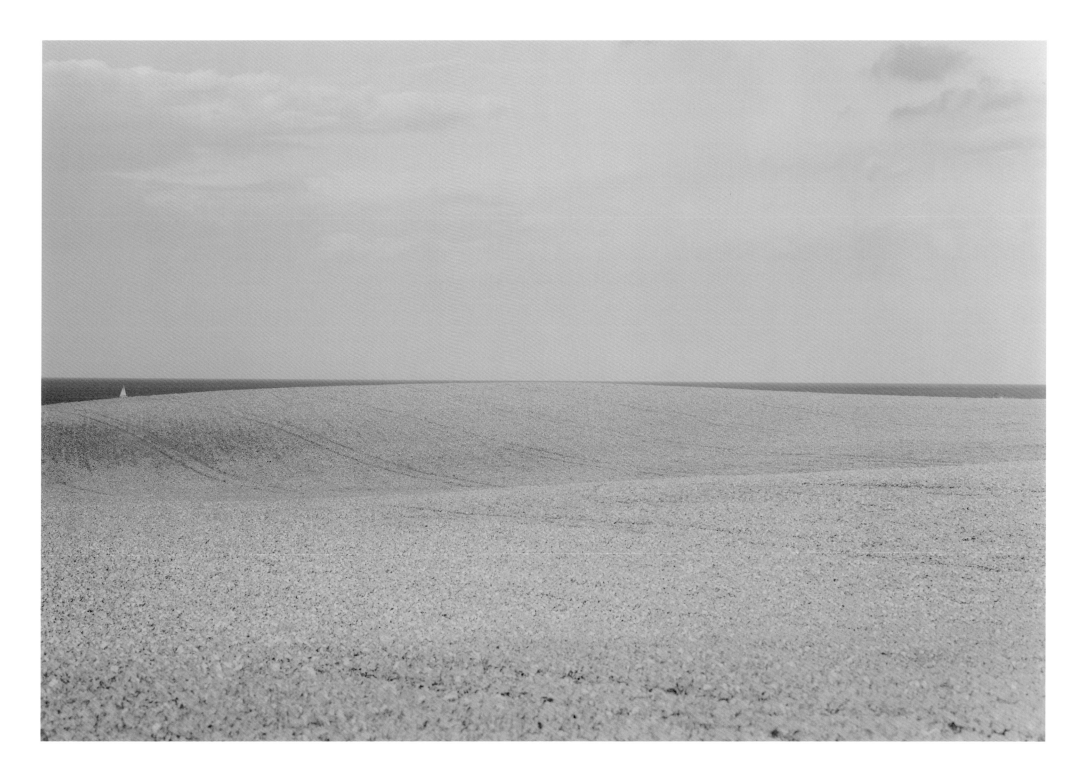

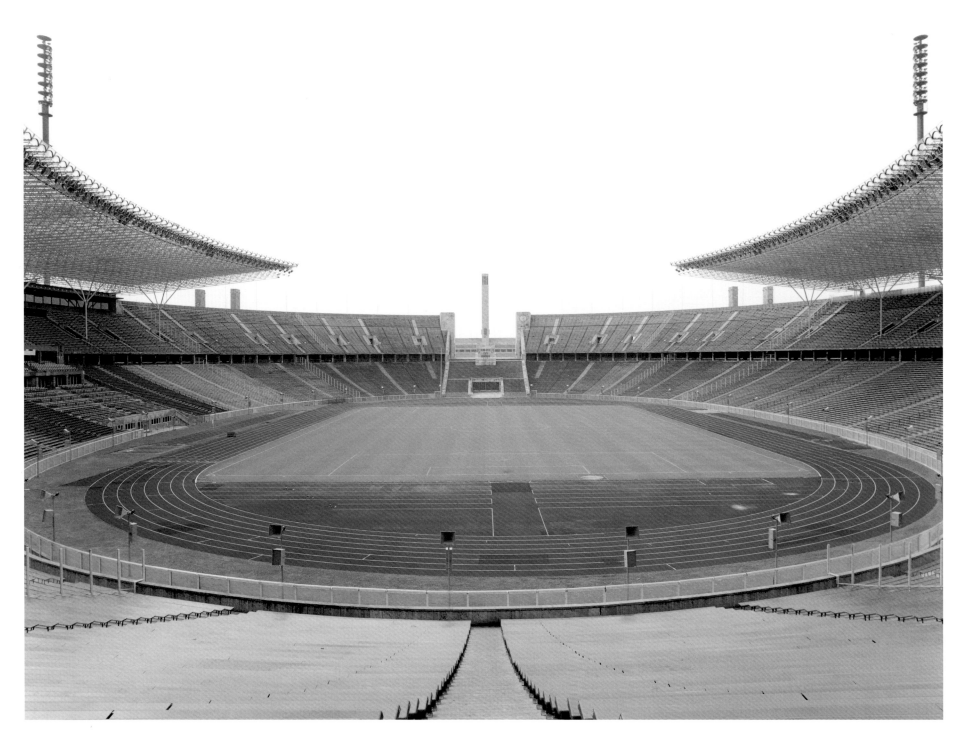

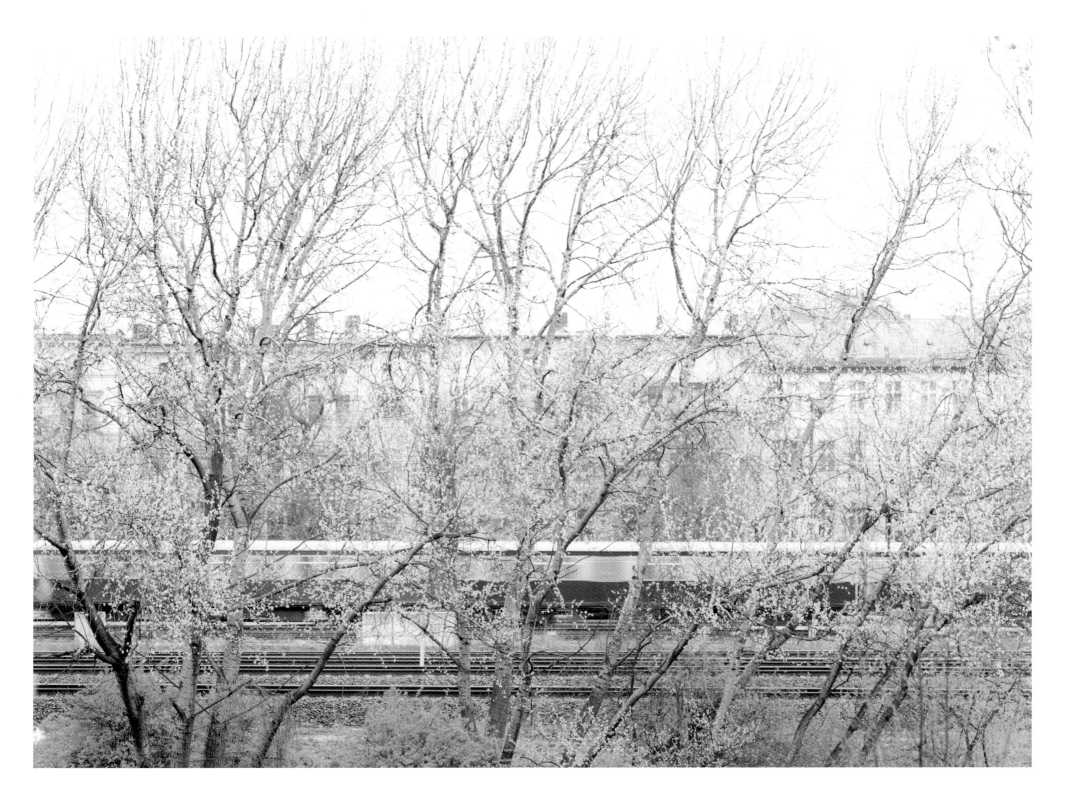

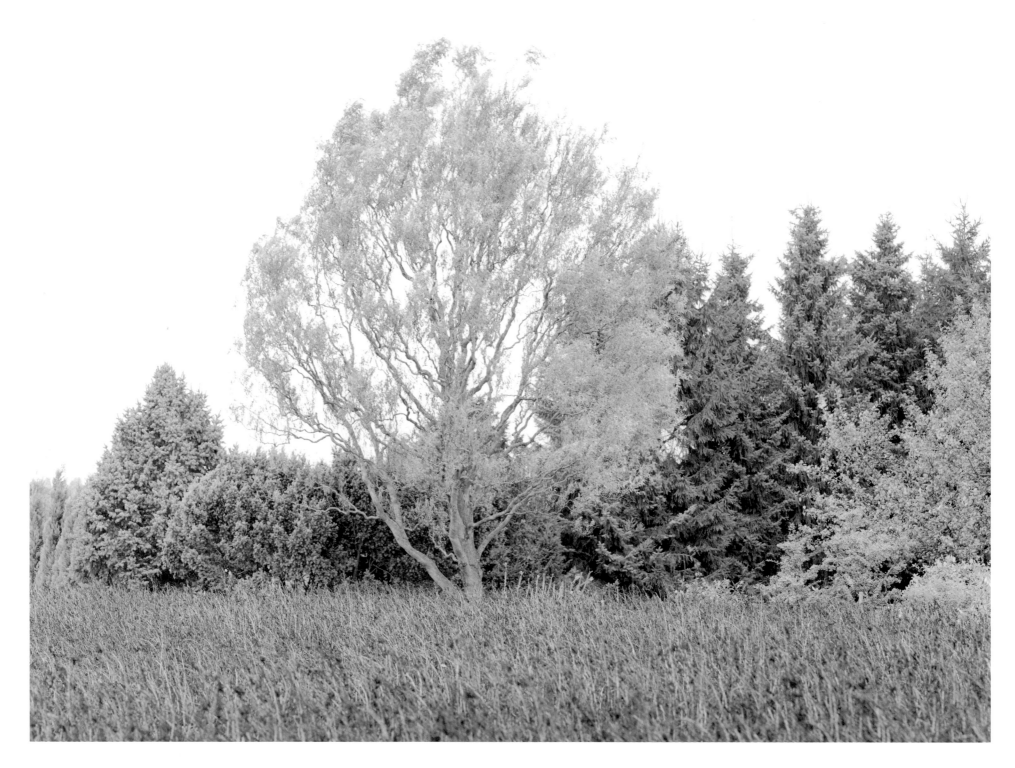

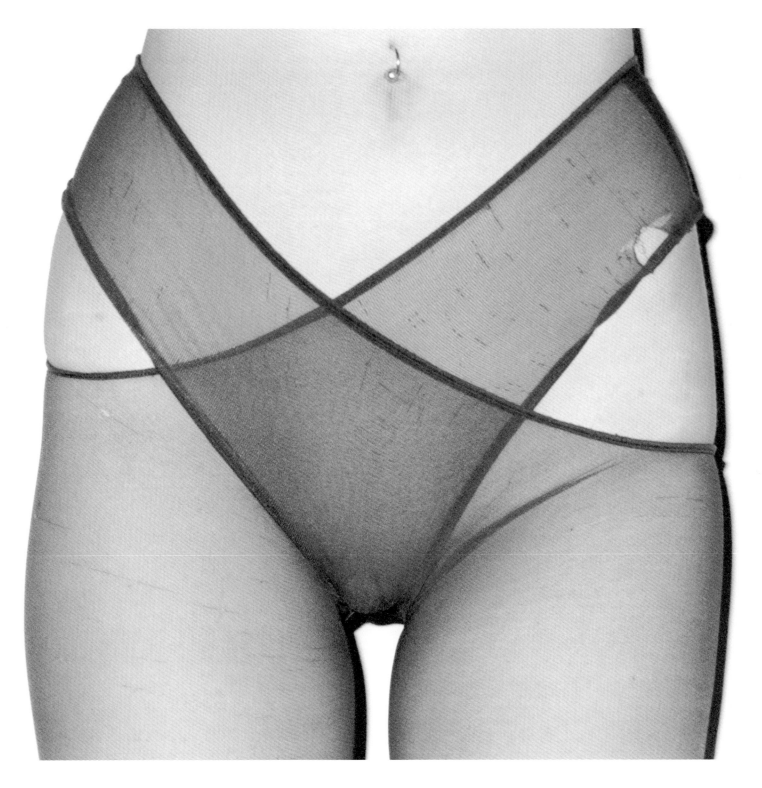

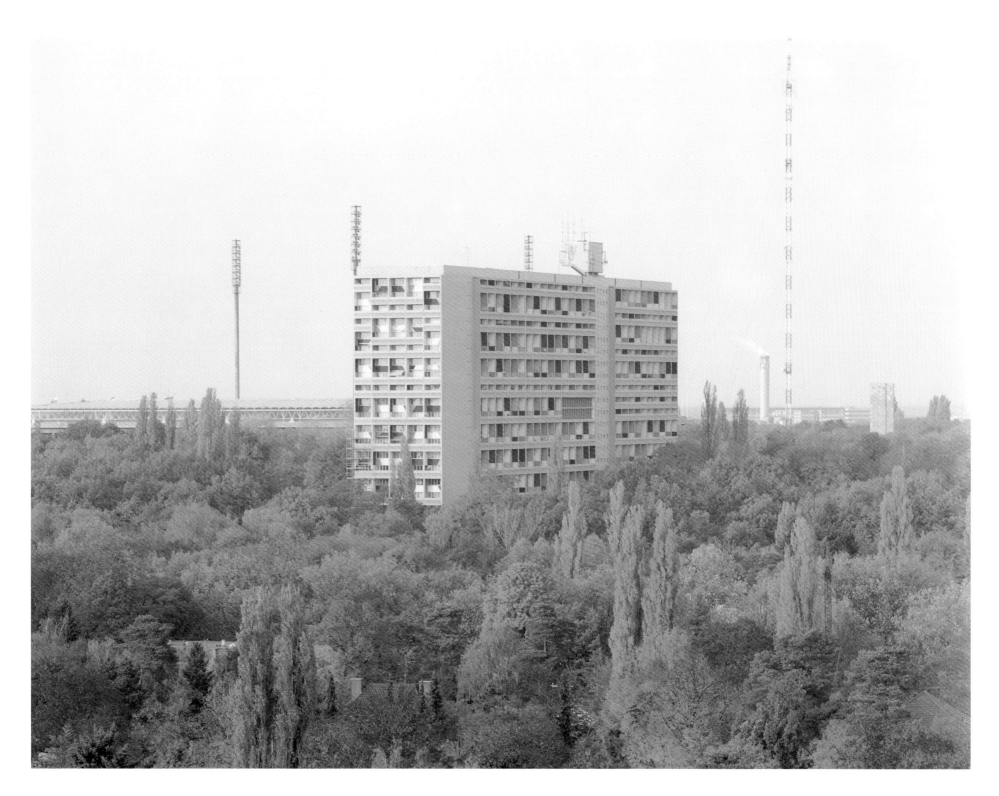

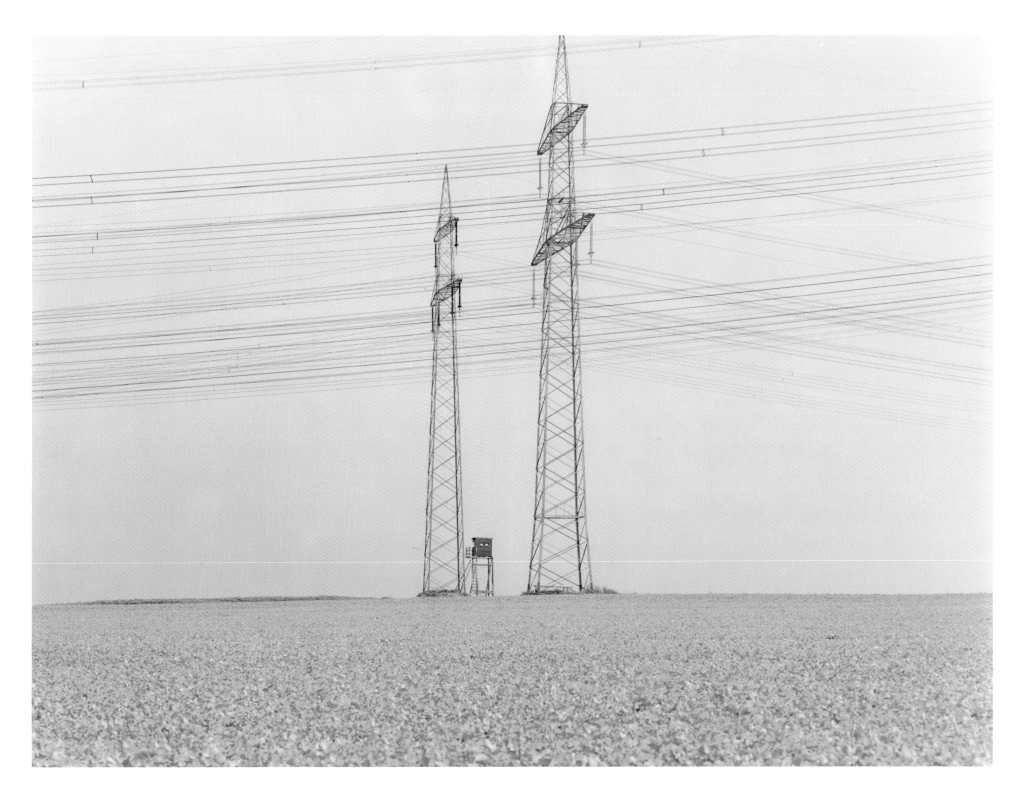

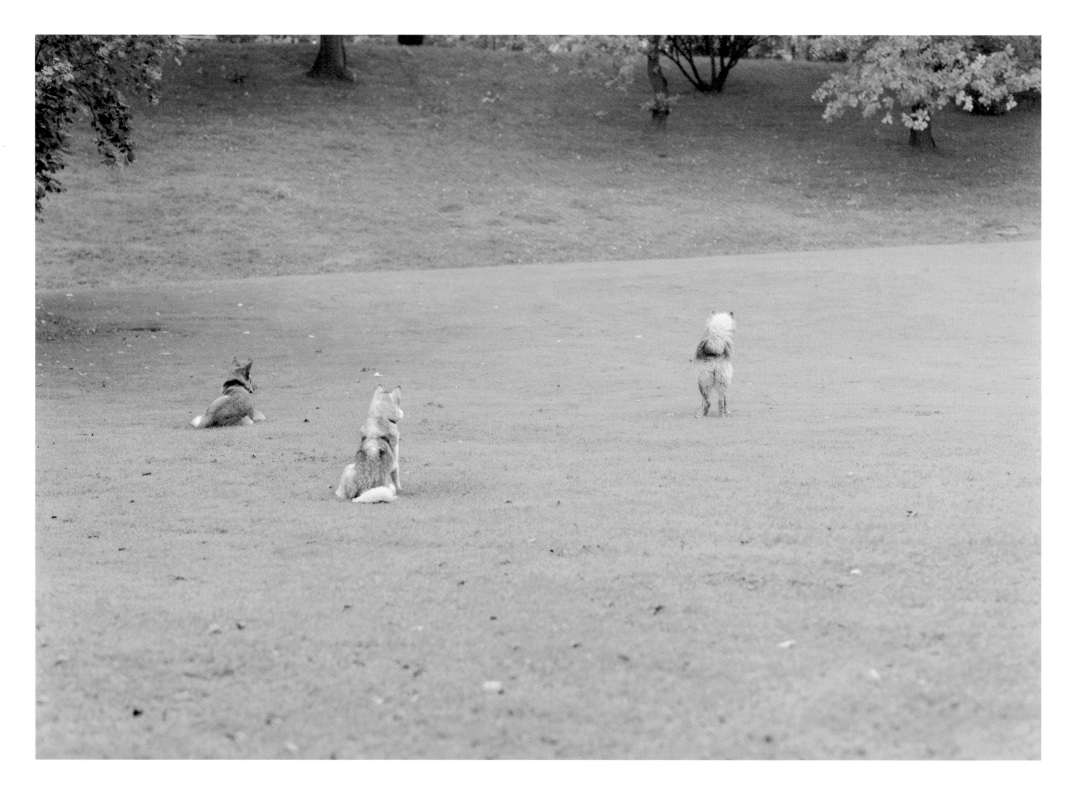

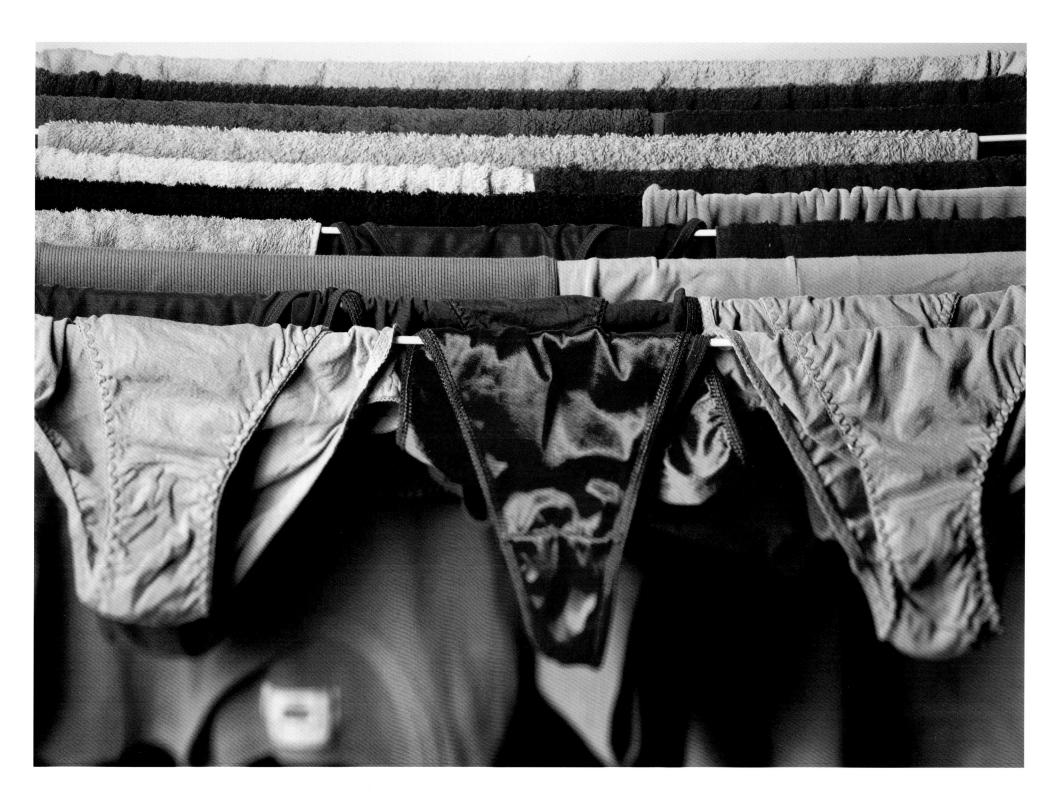

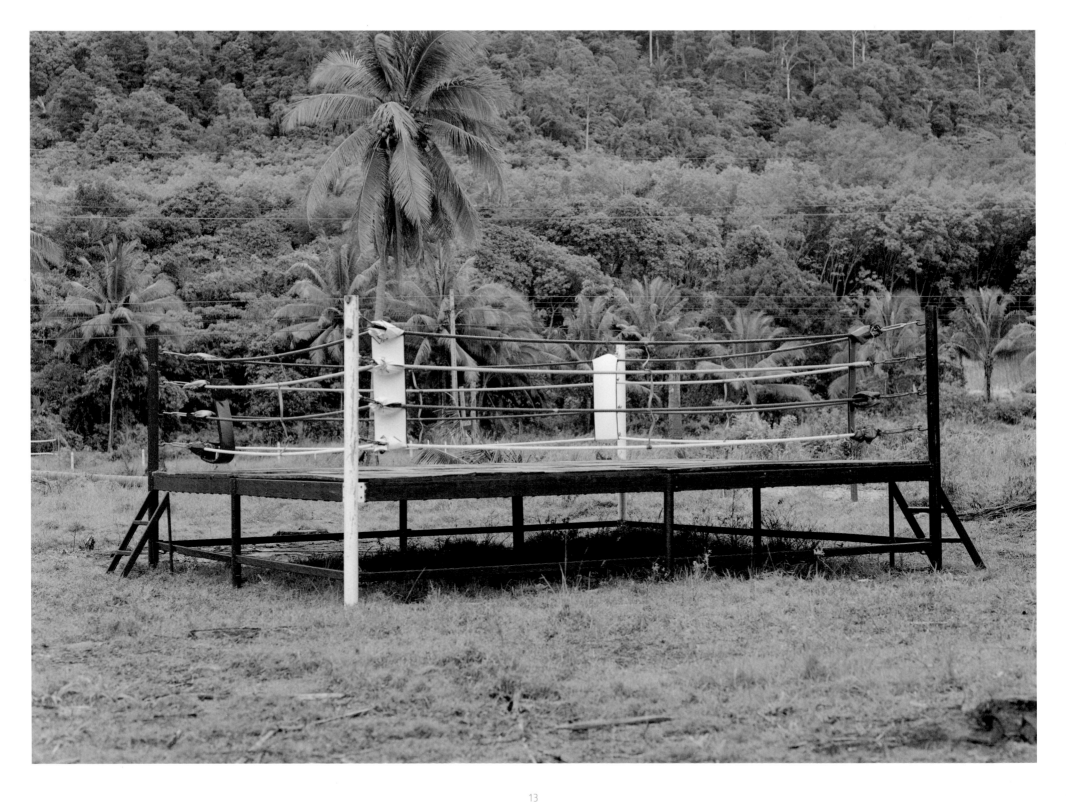

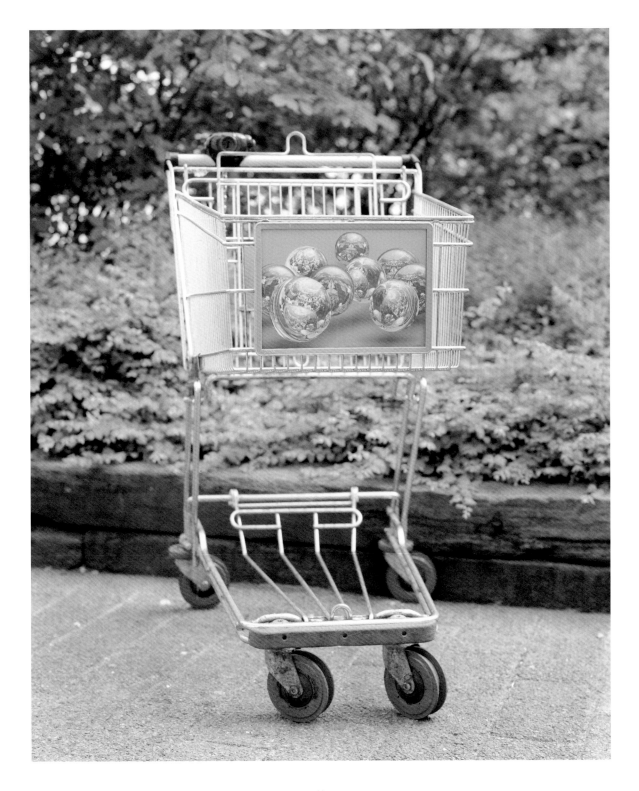

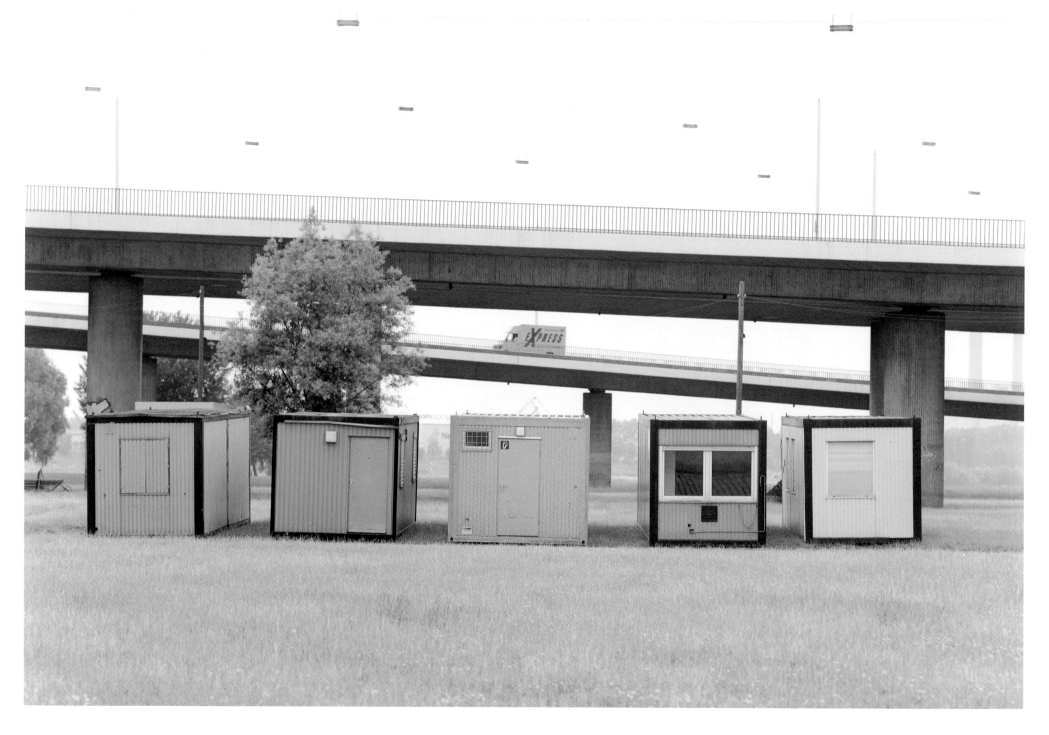

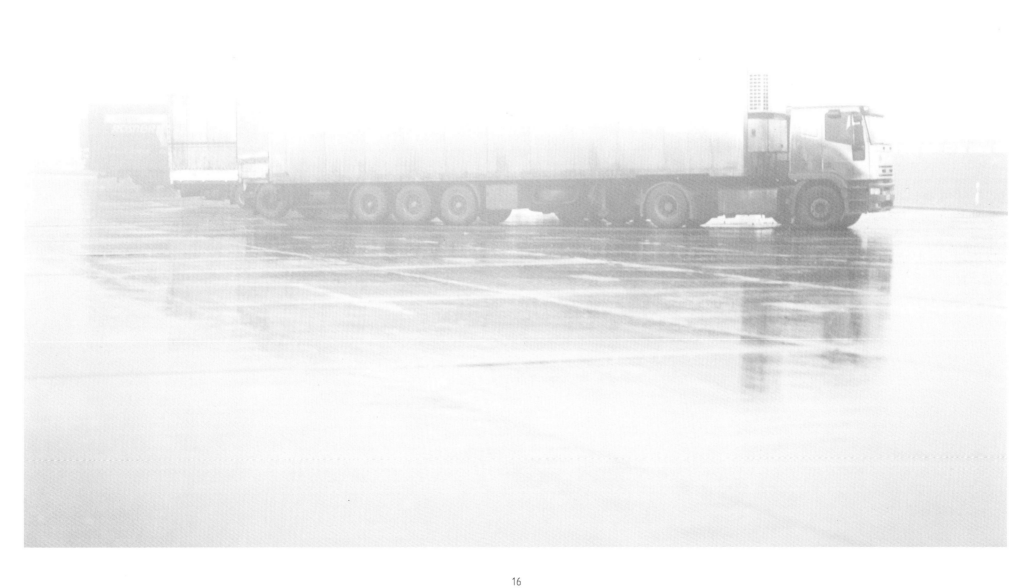

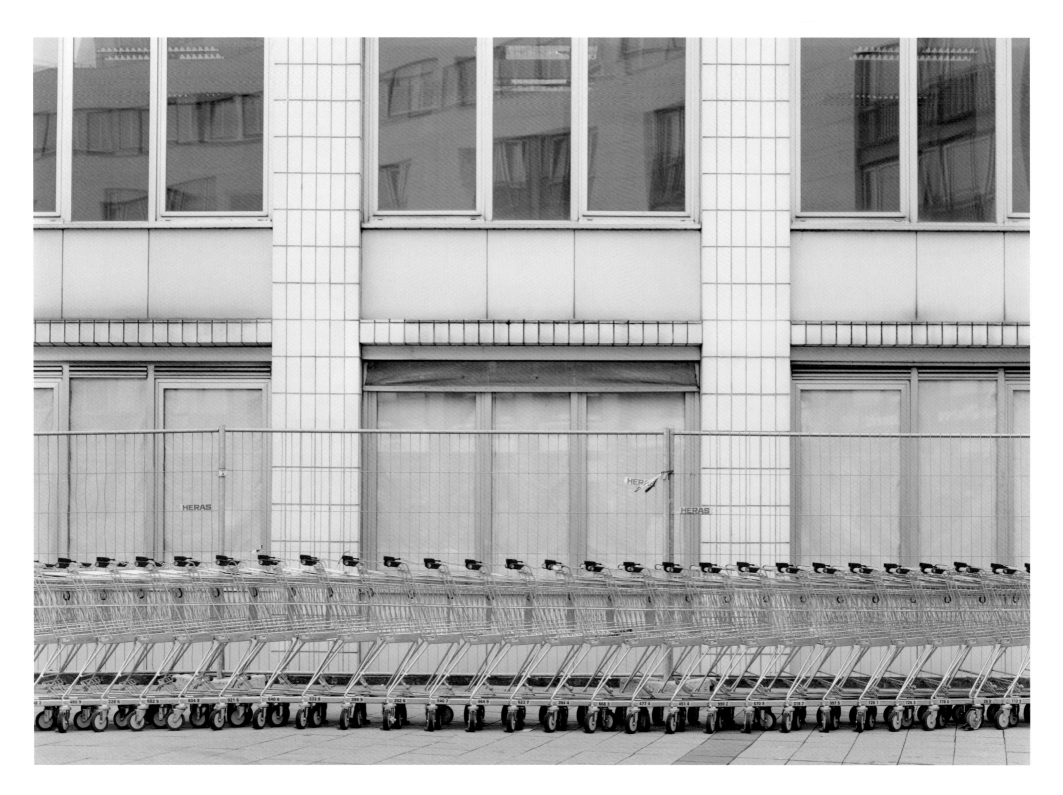

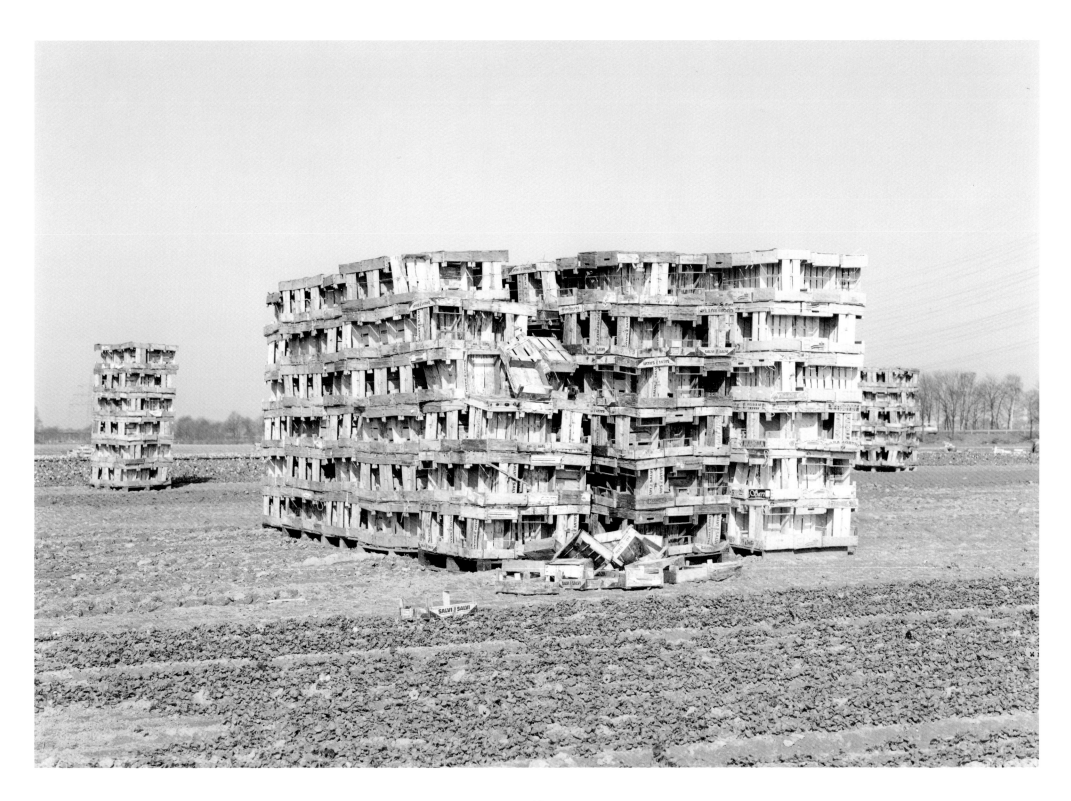

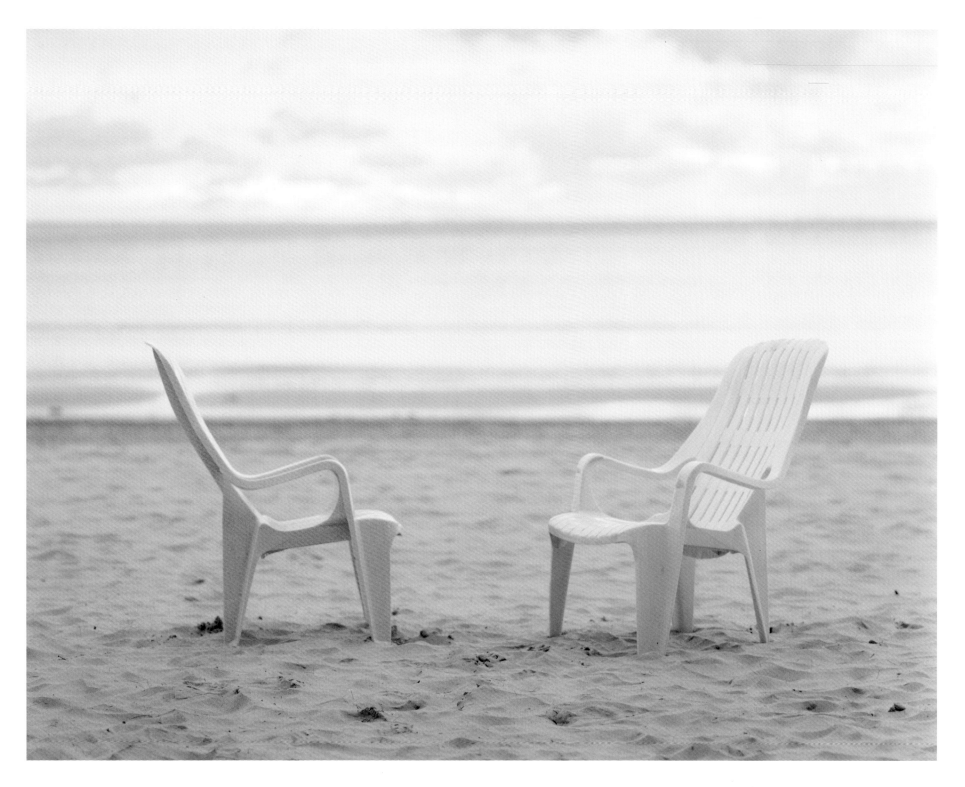

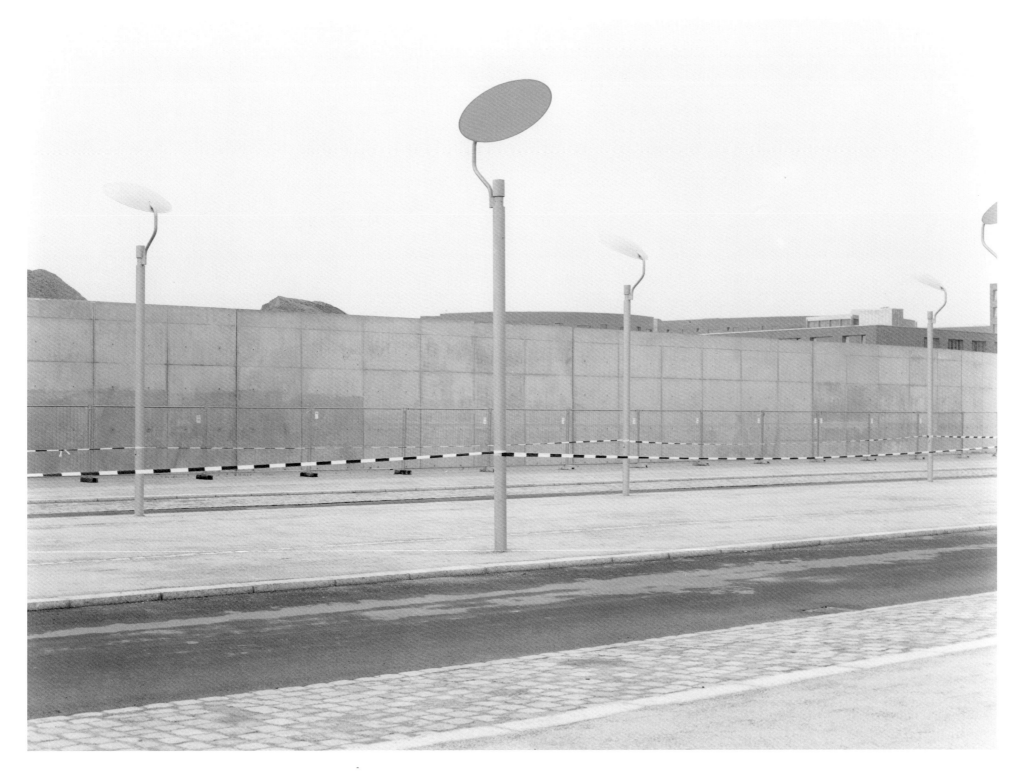

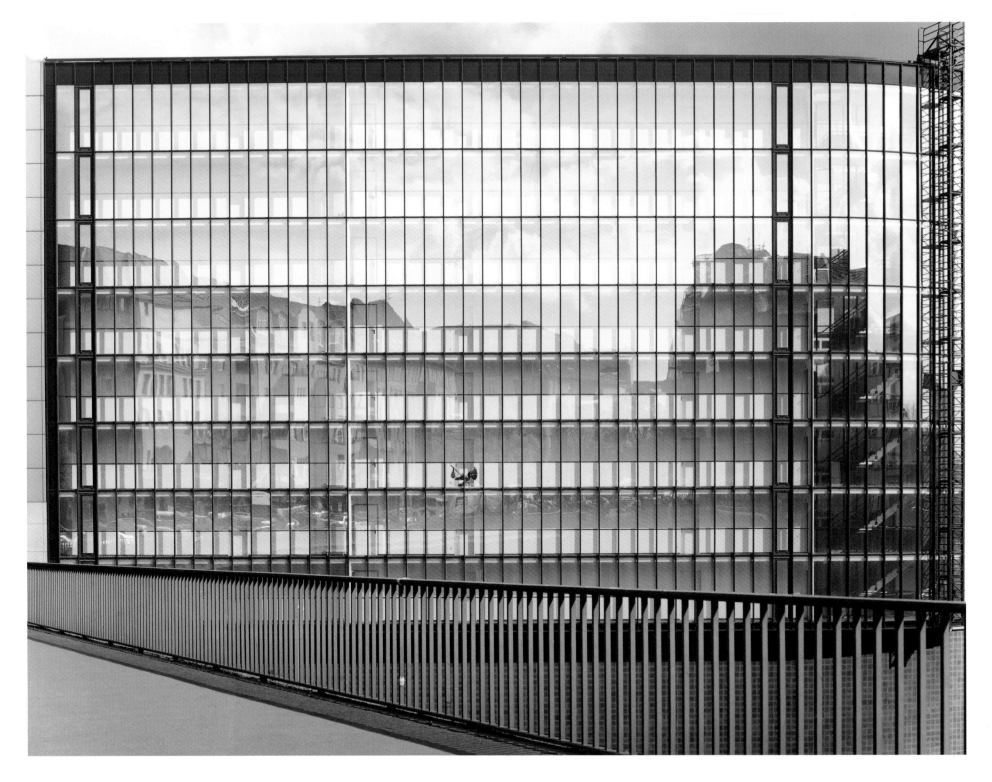

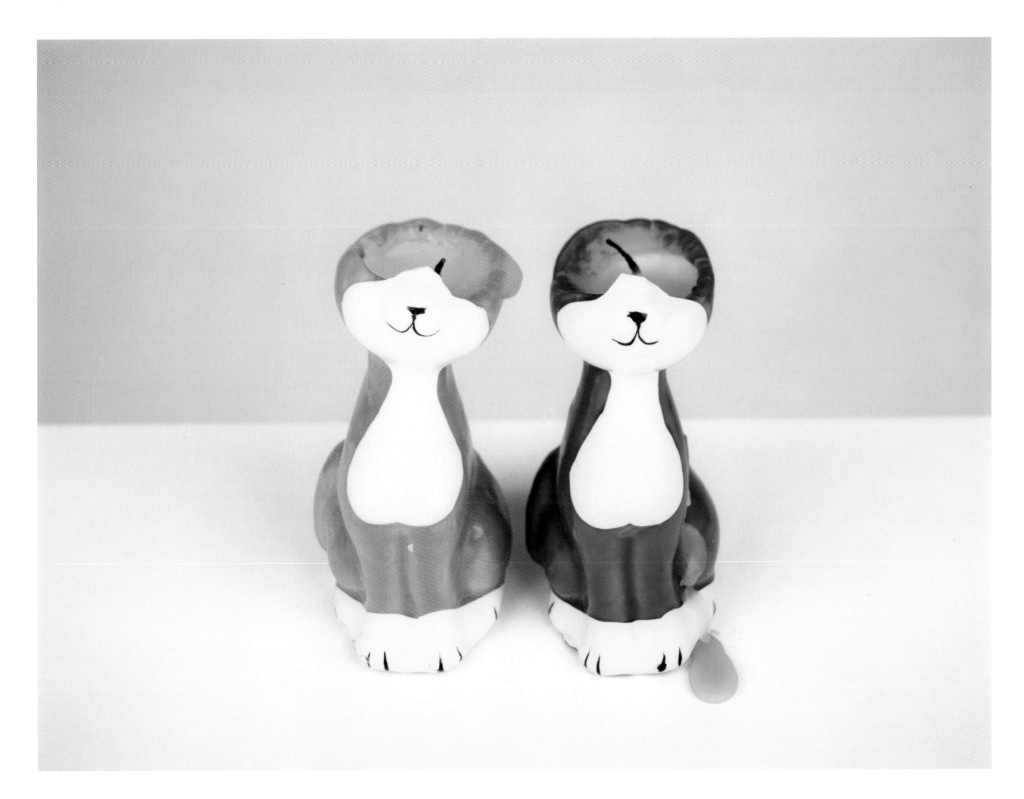

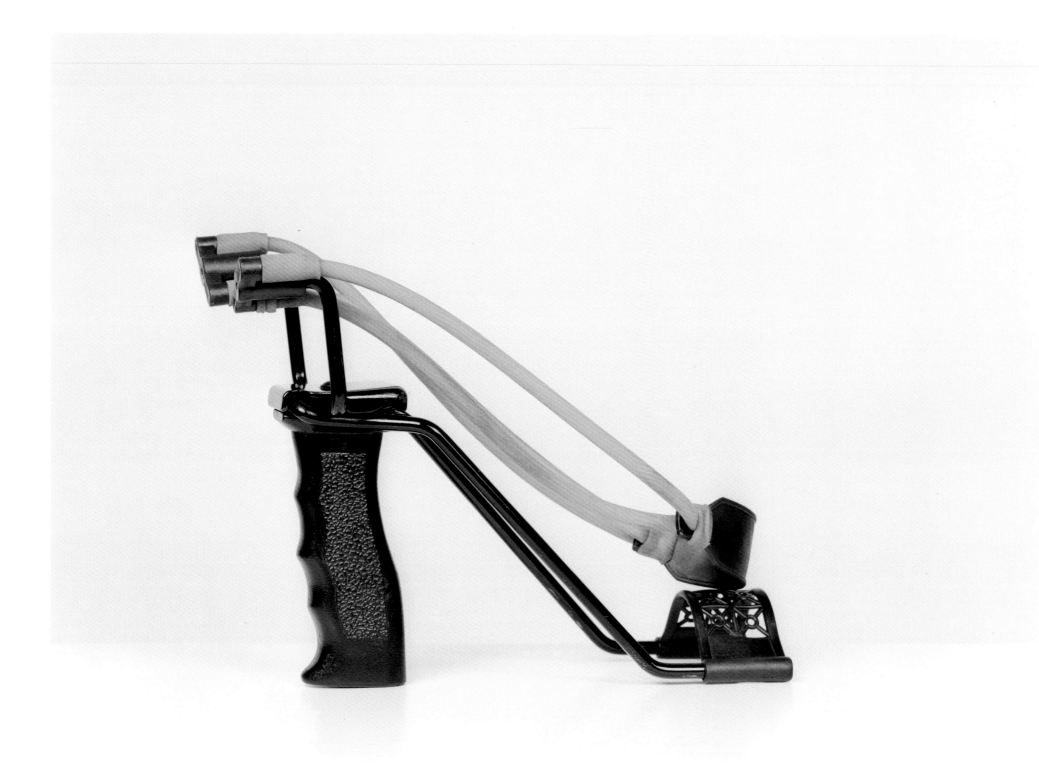

23

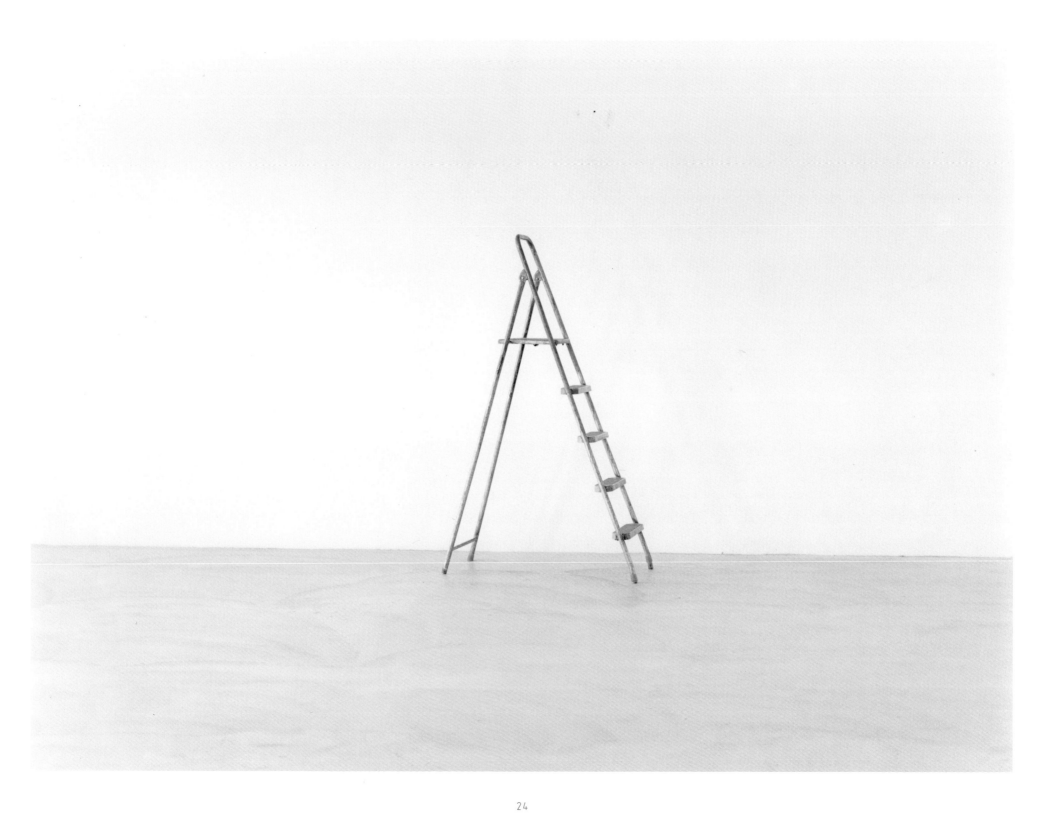

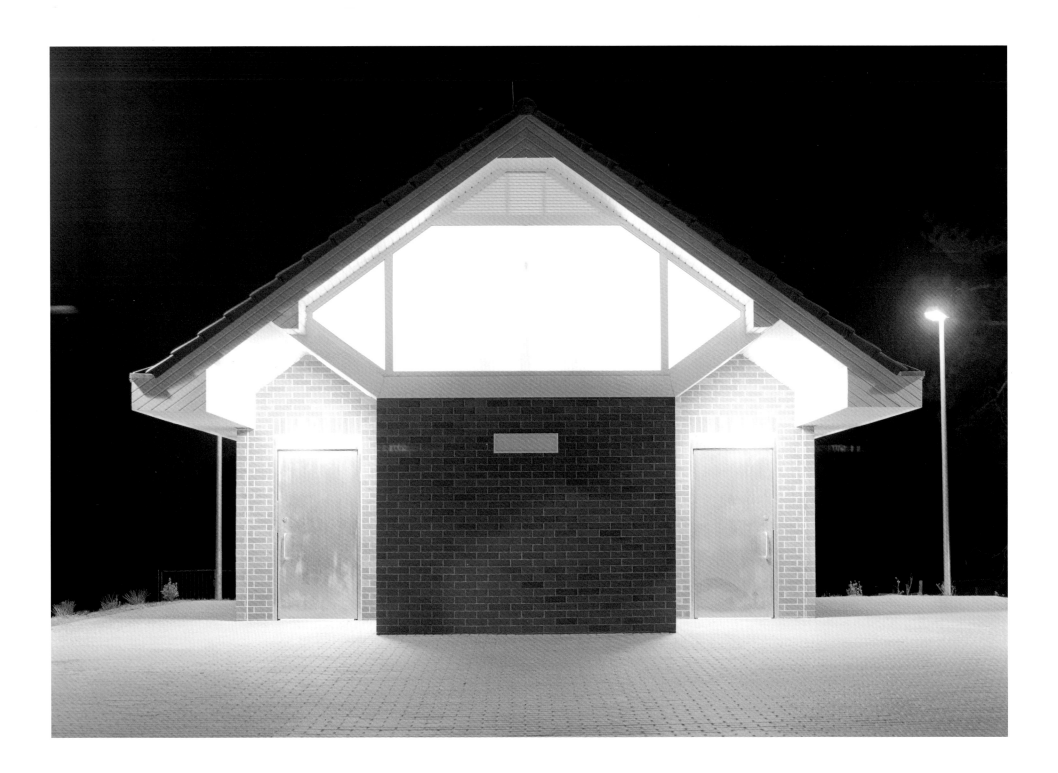

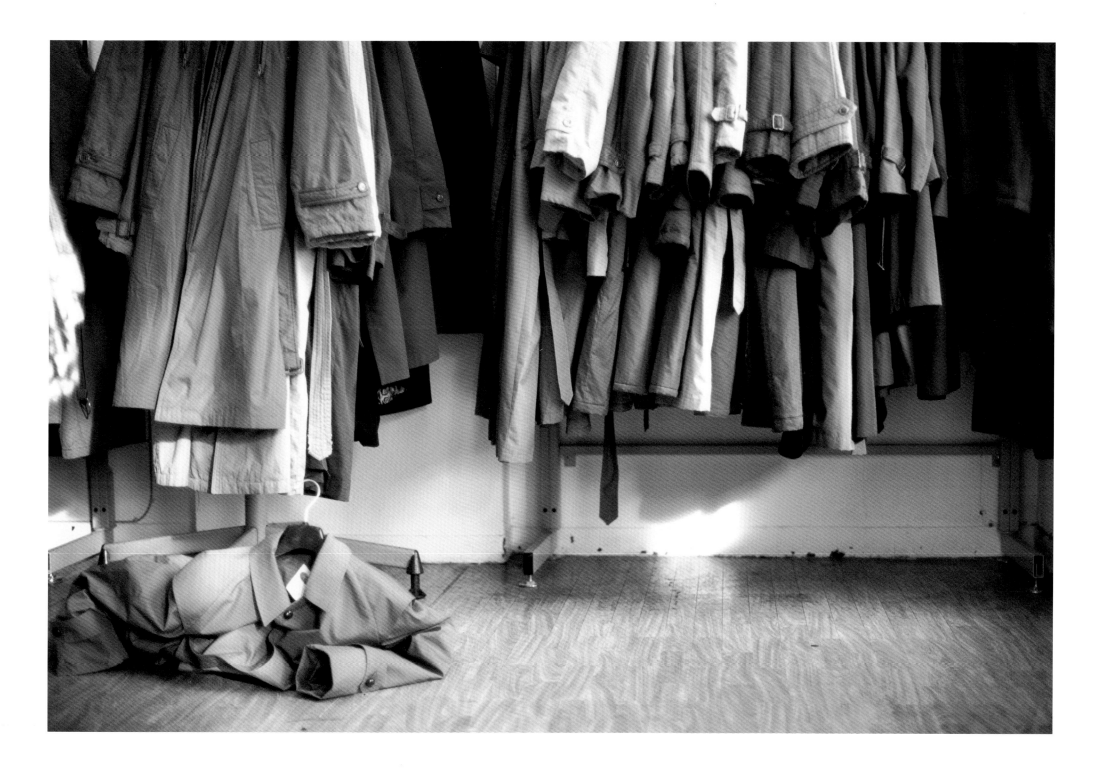

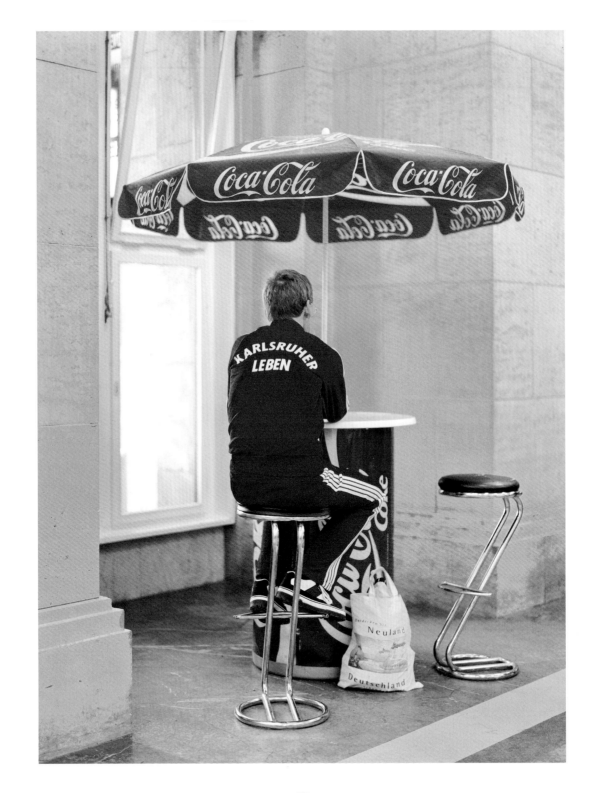

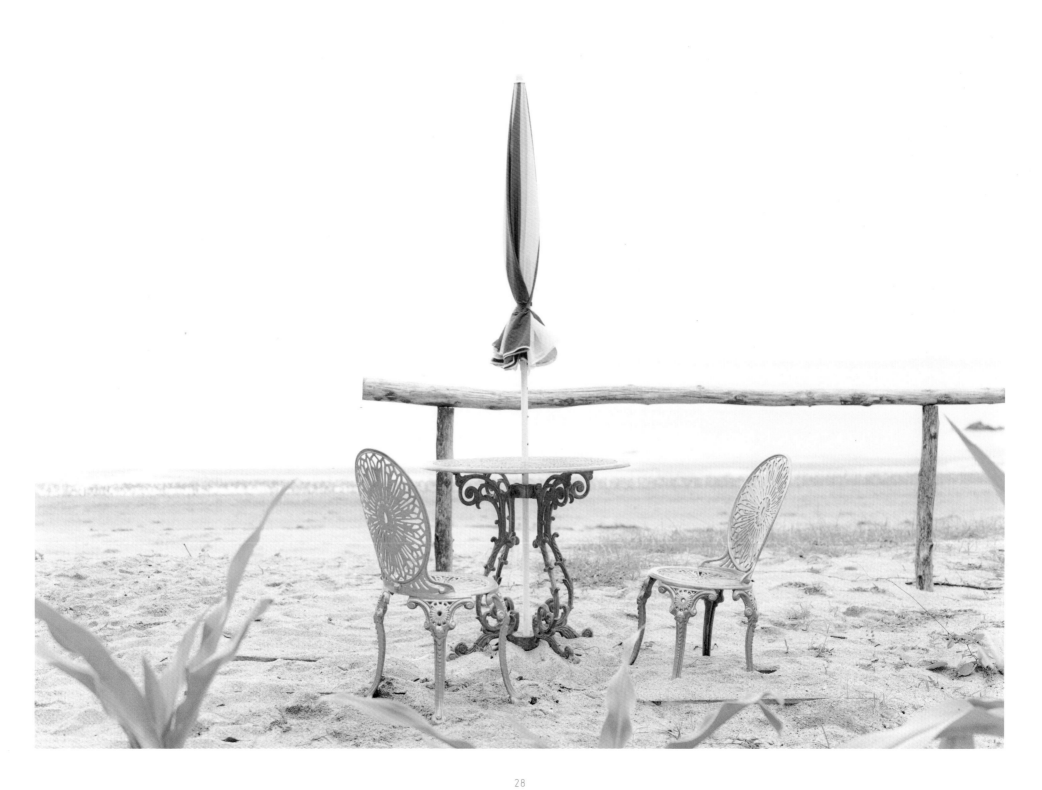

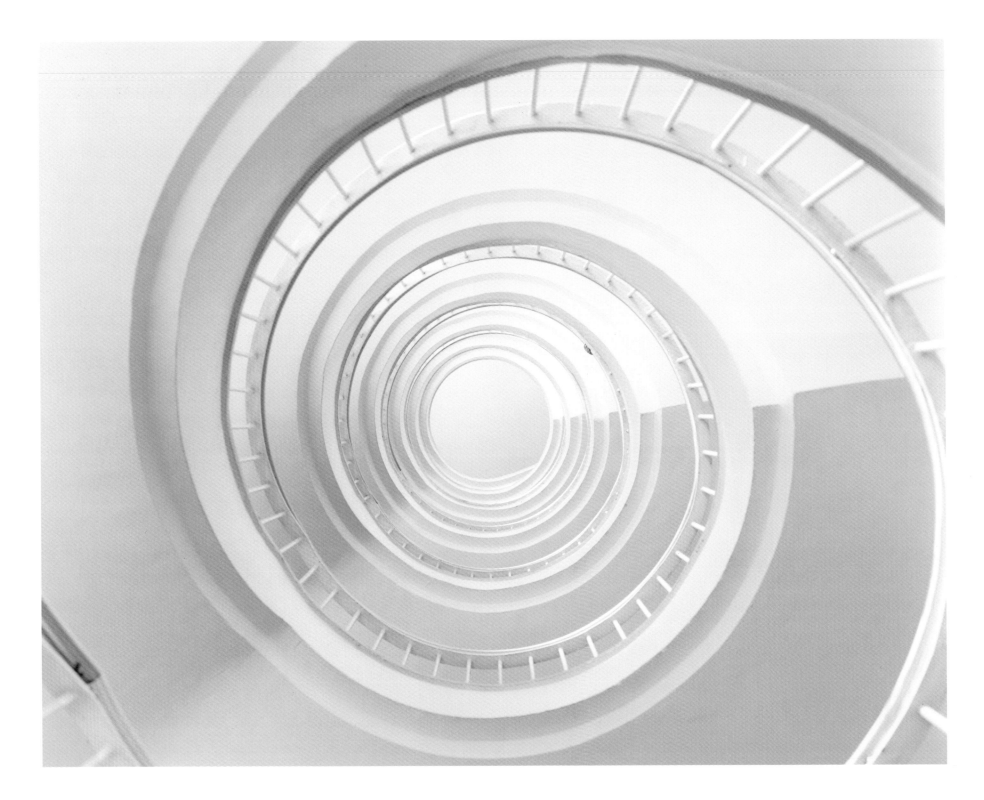

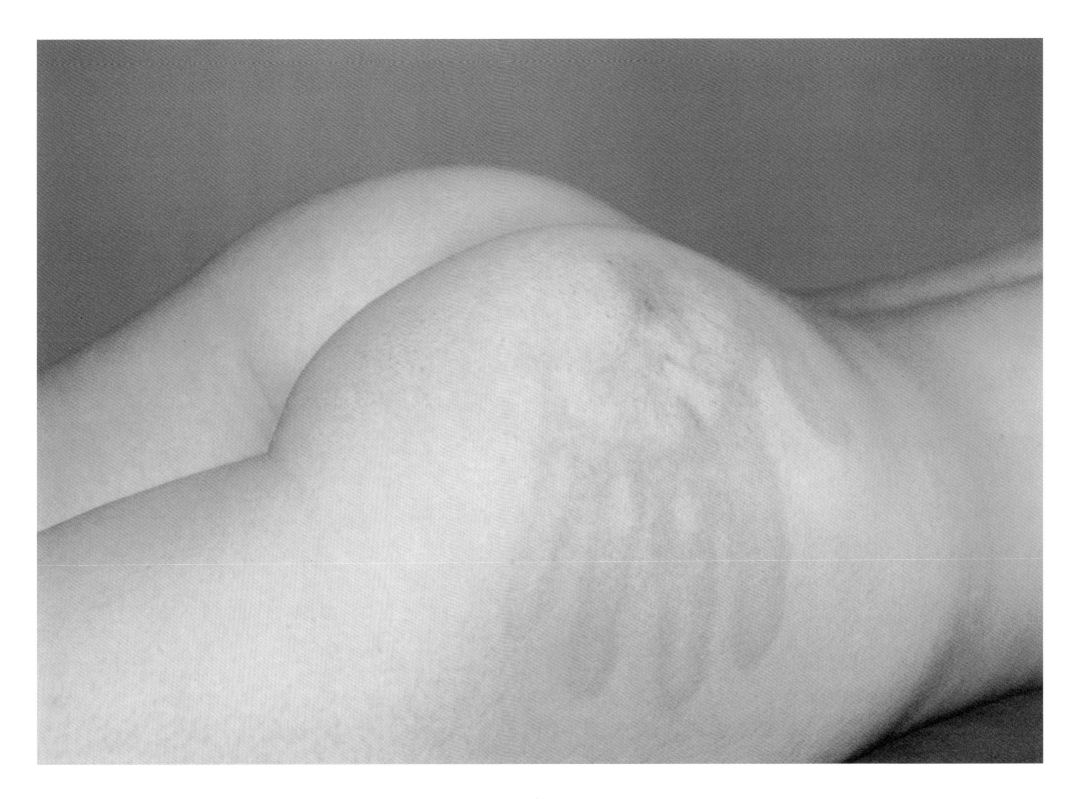

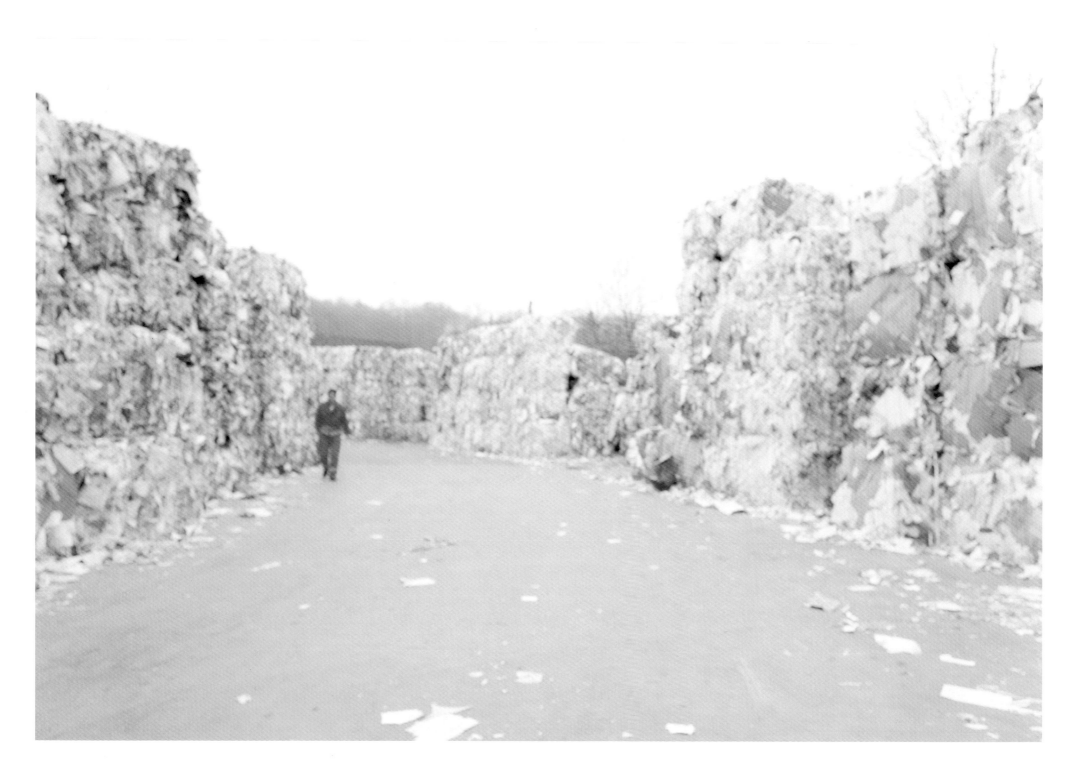

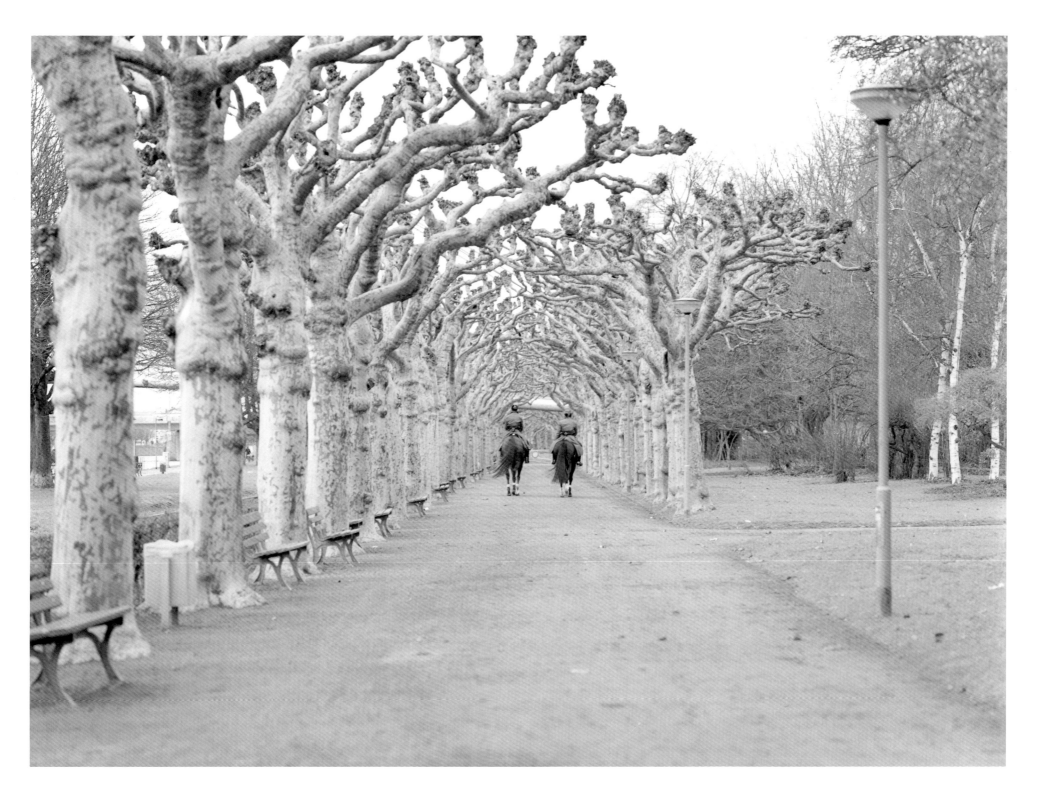

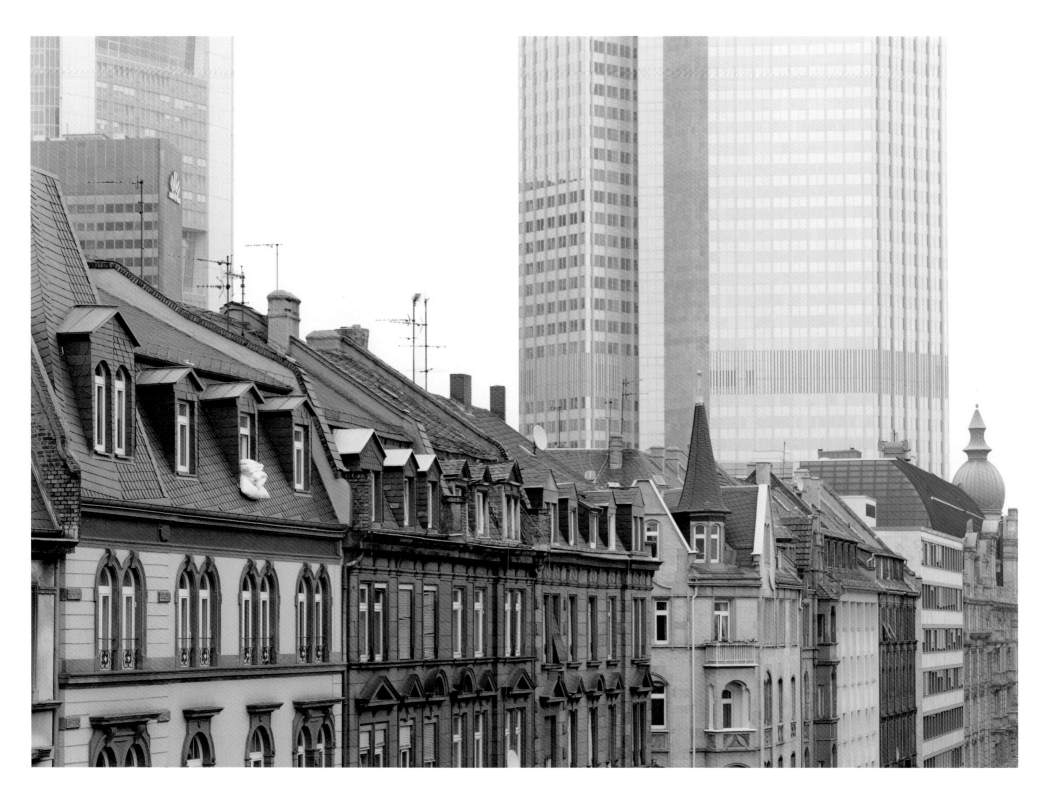

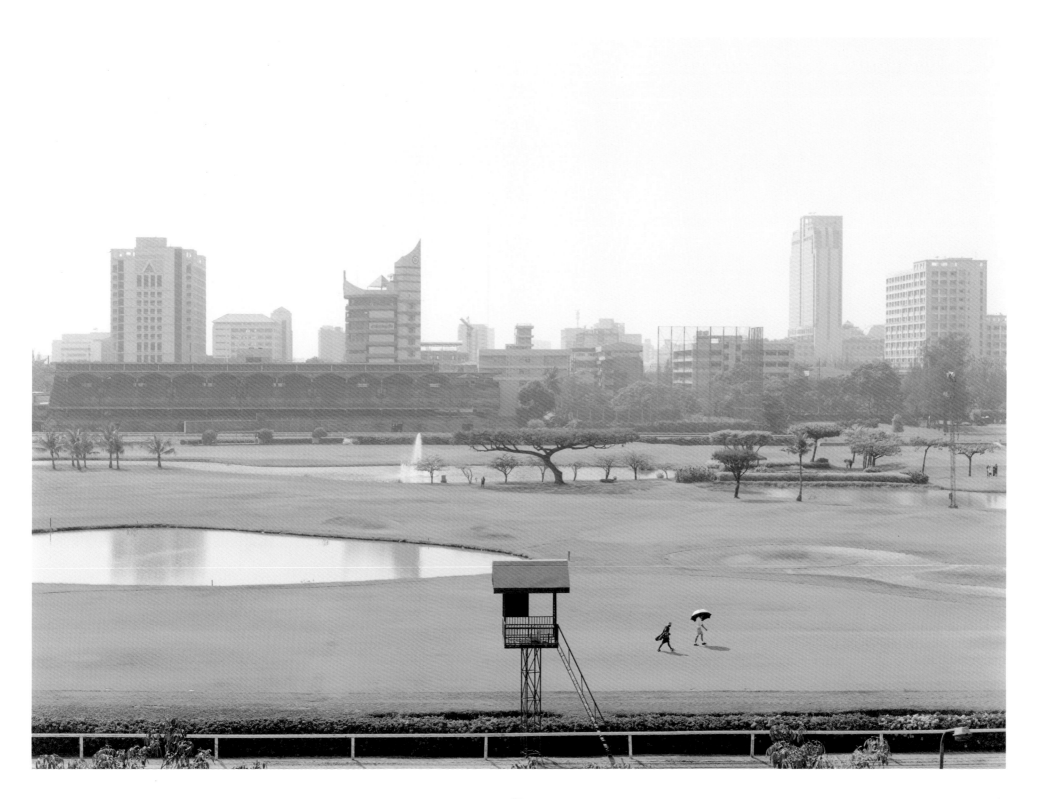

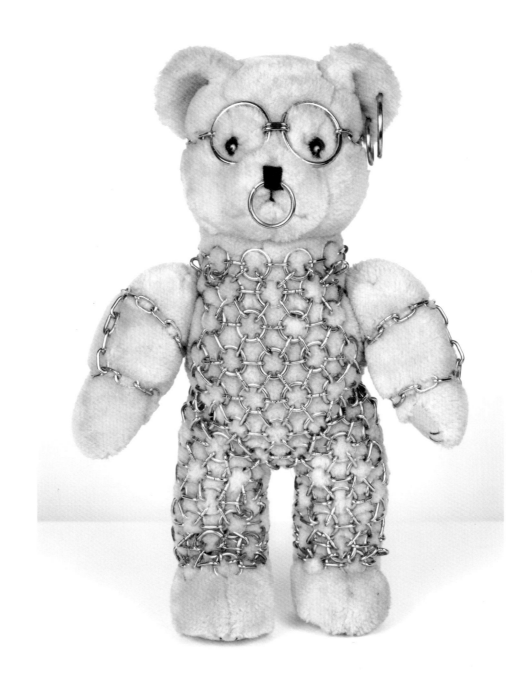

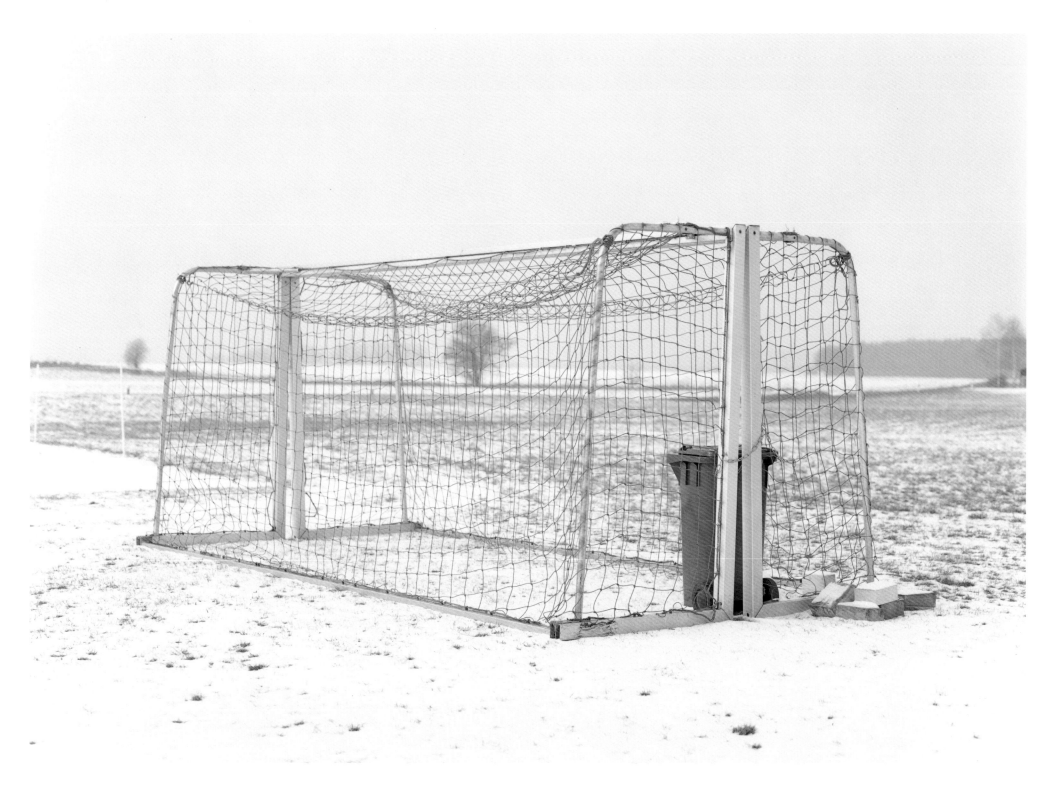

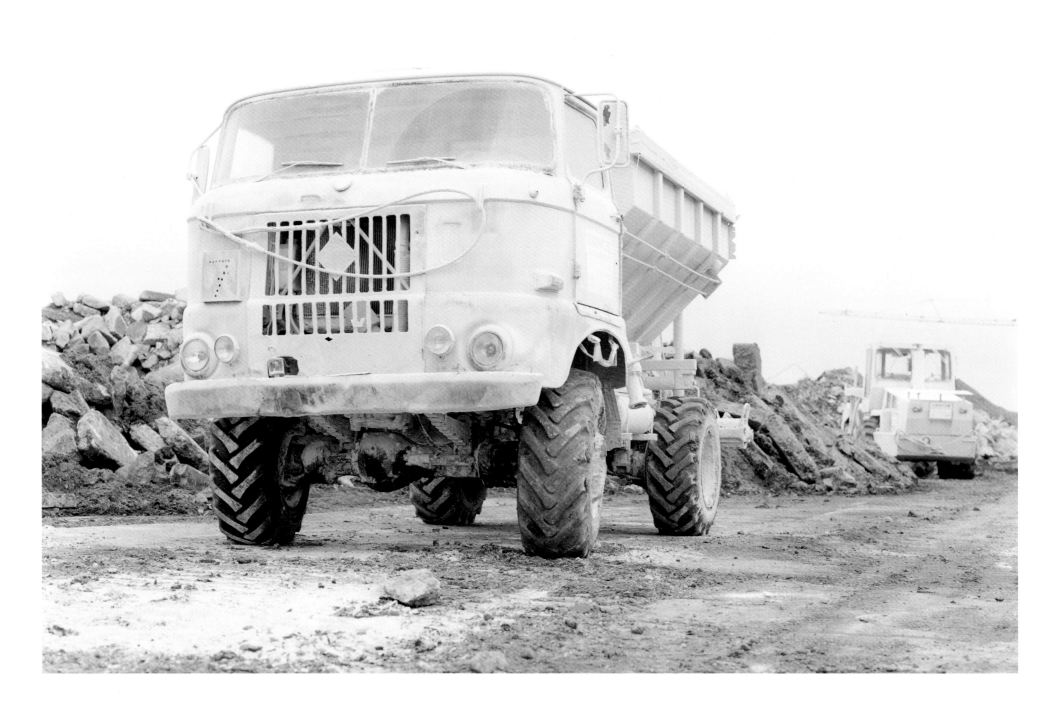

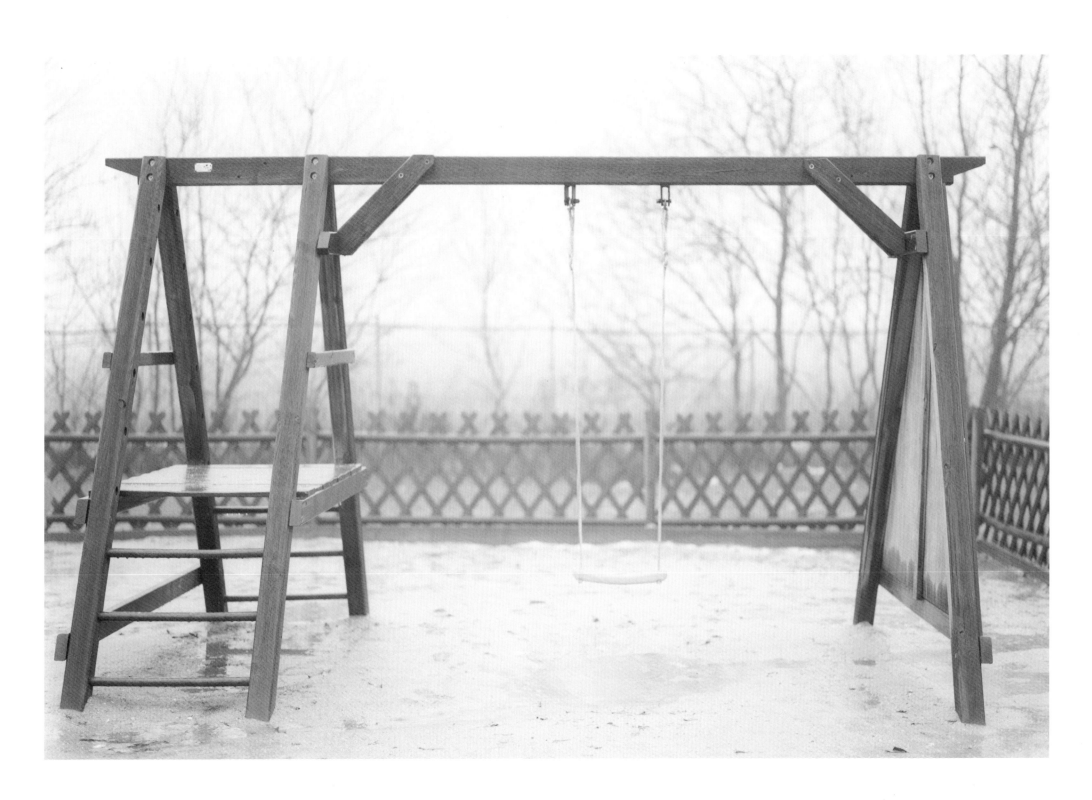

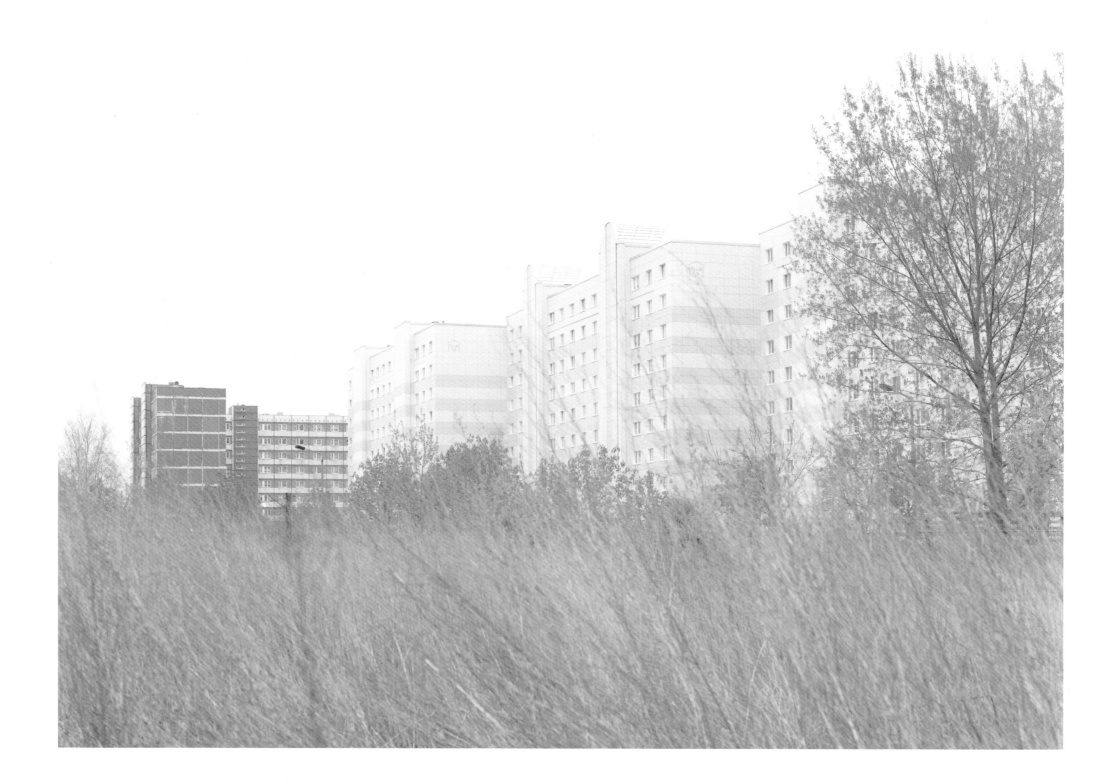

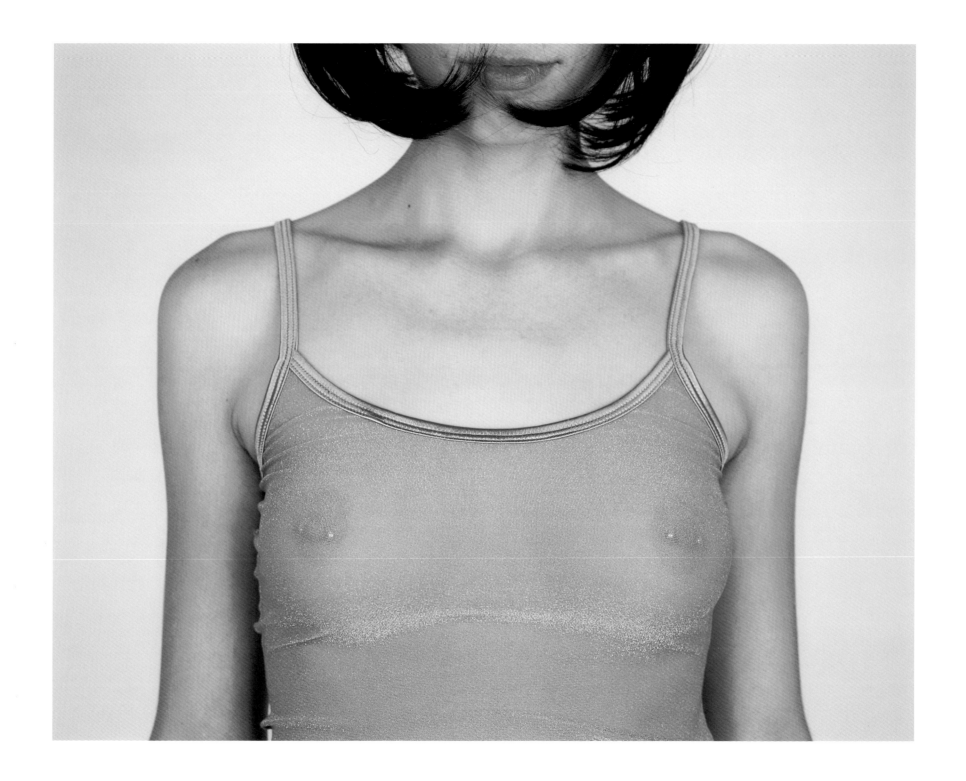

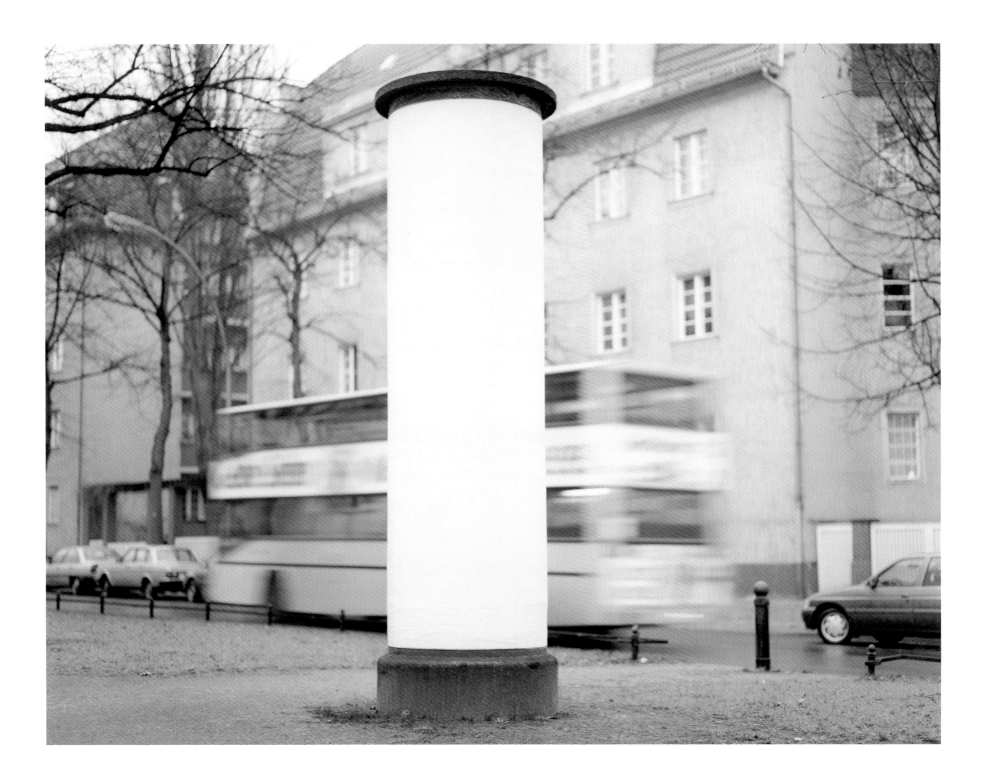

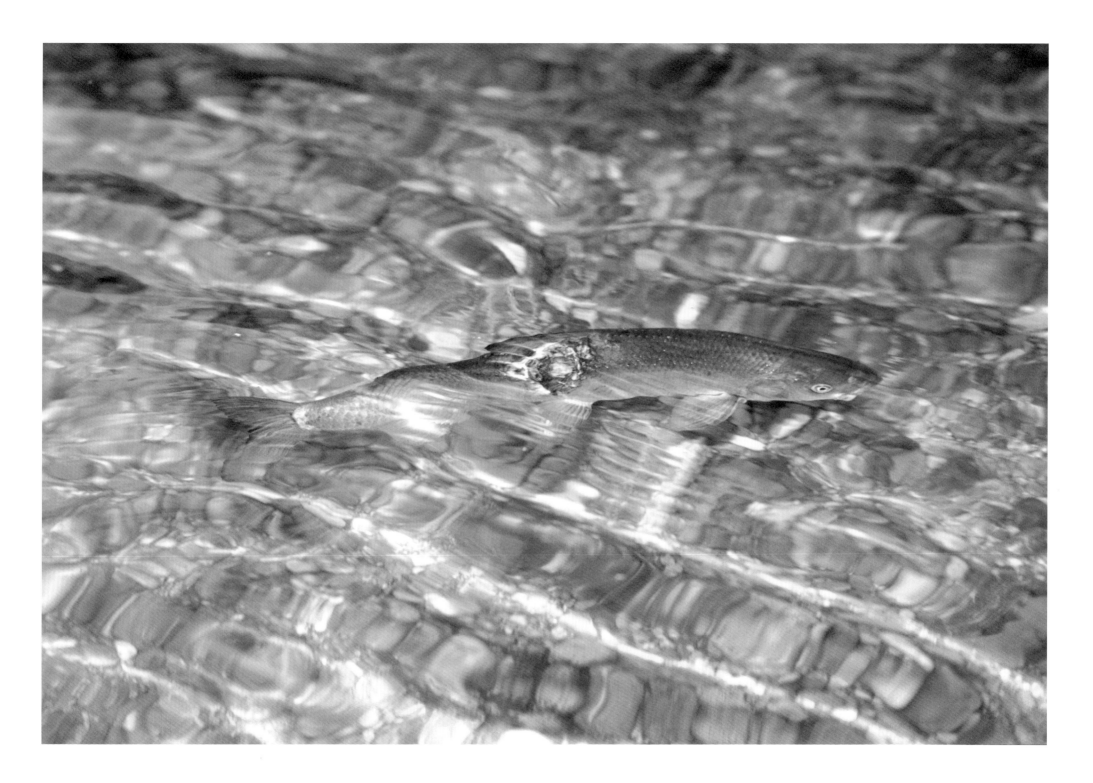

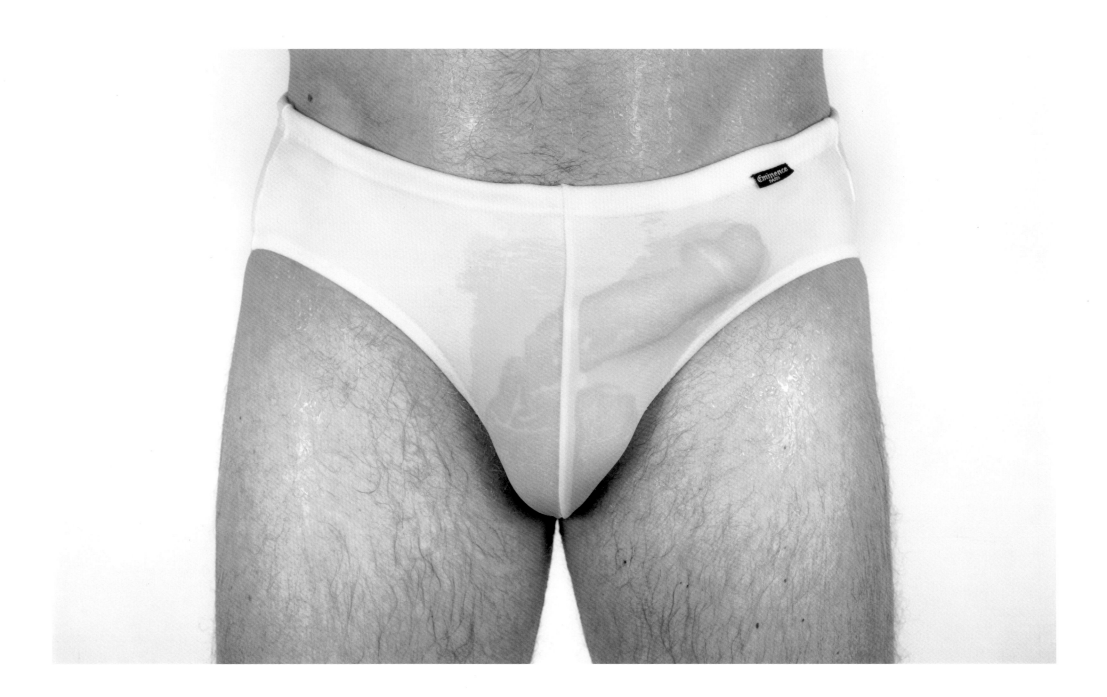

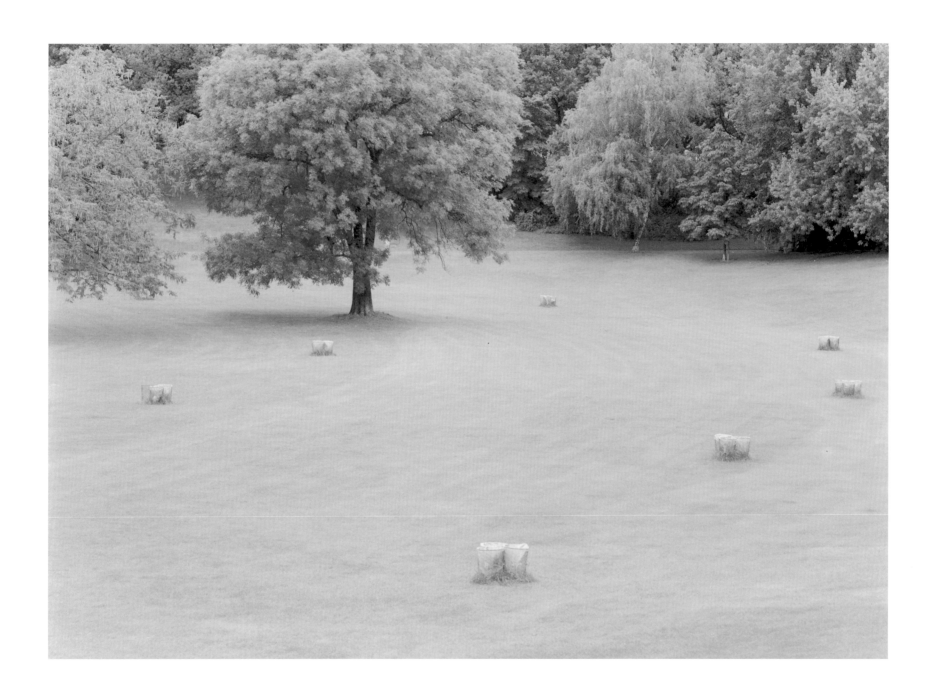

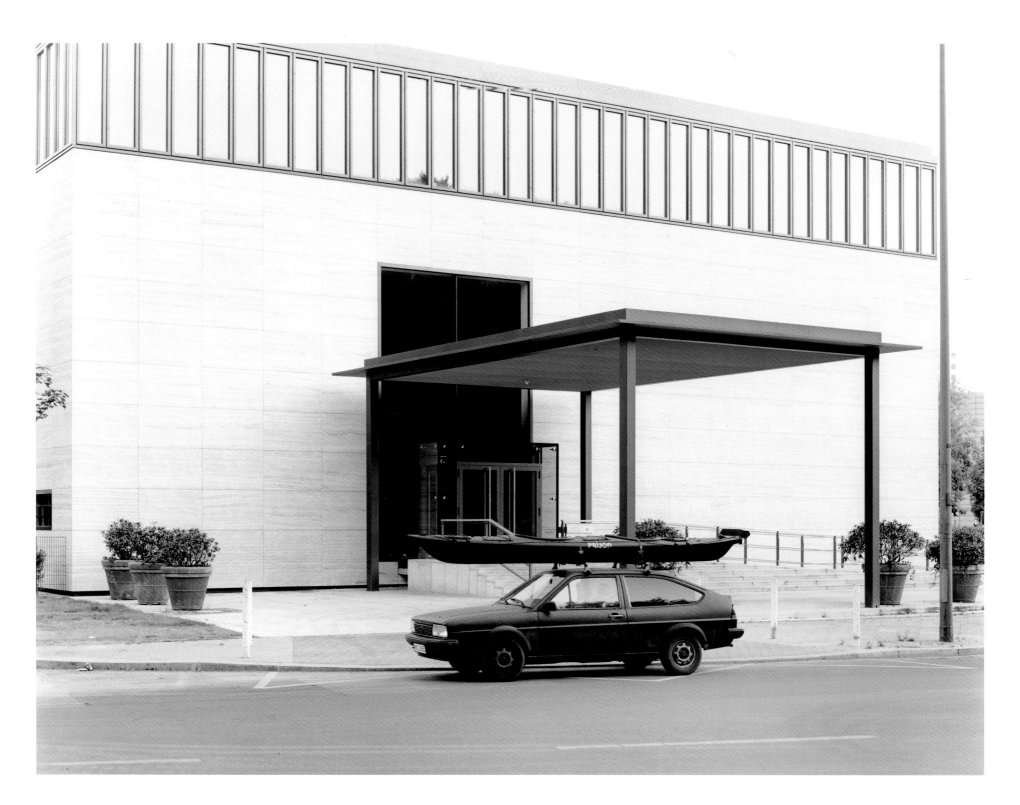

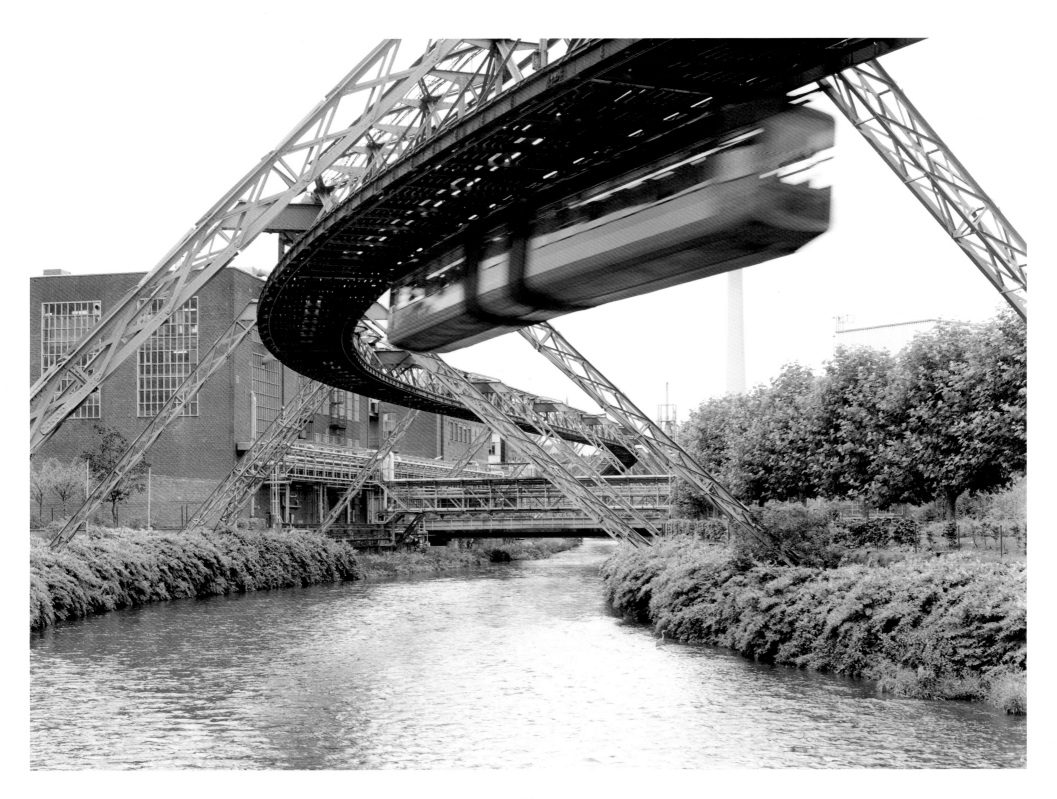

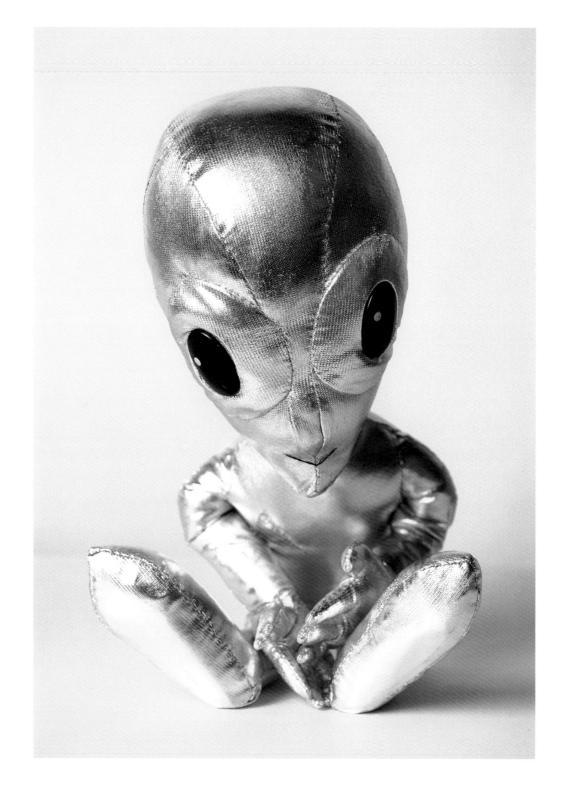

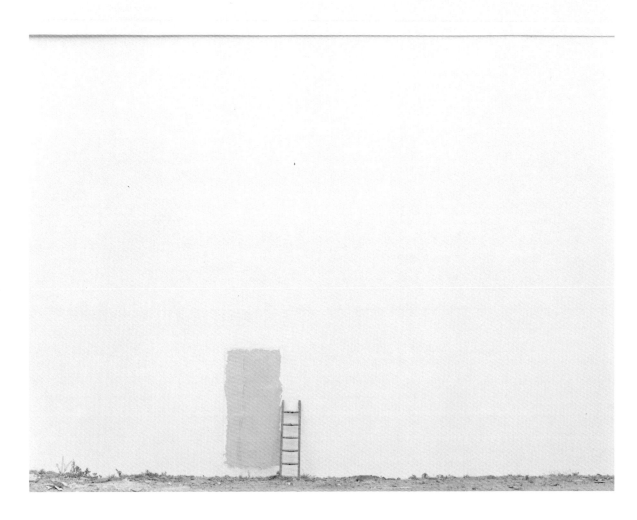

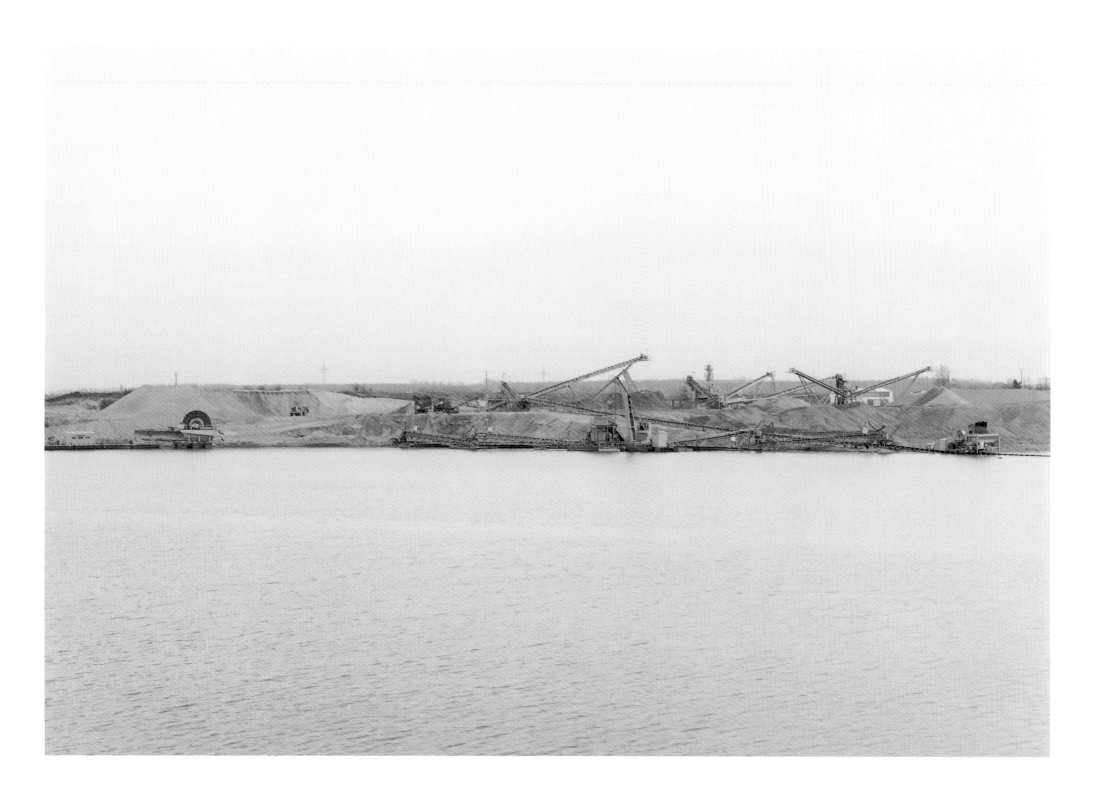

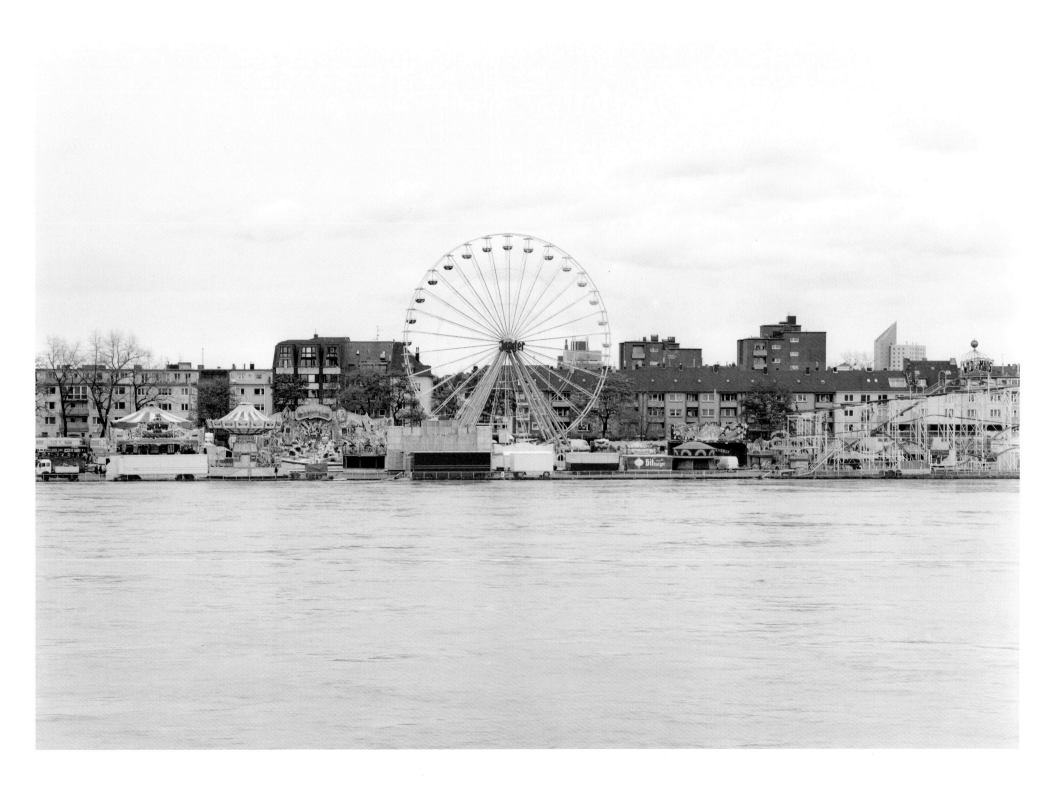

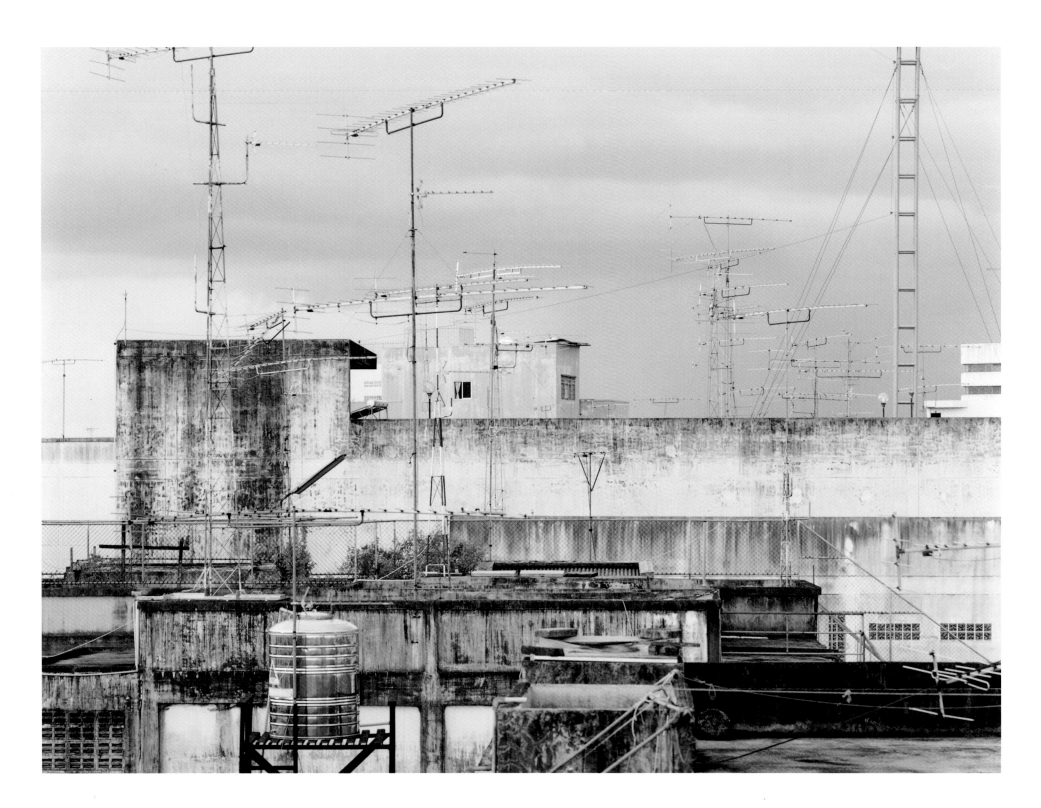

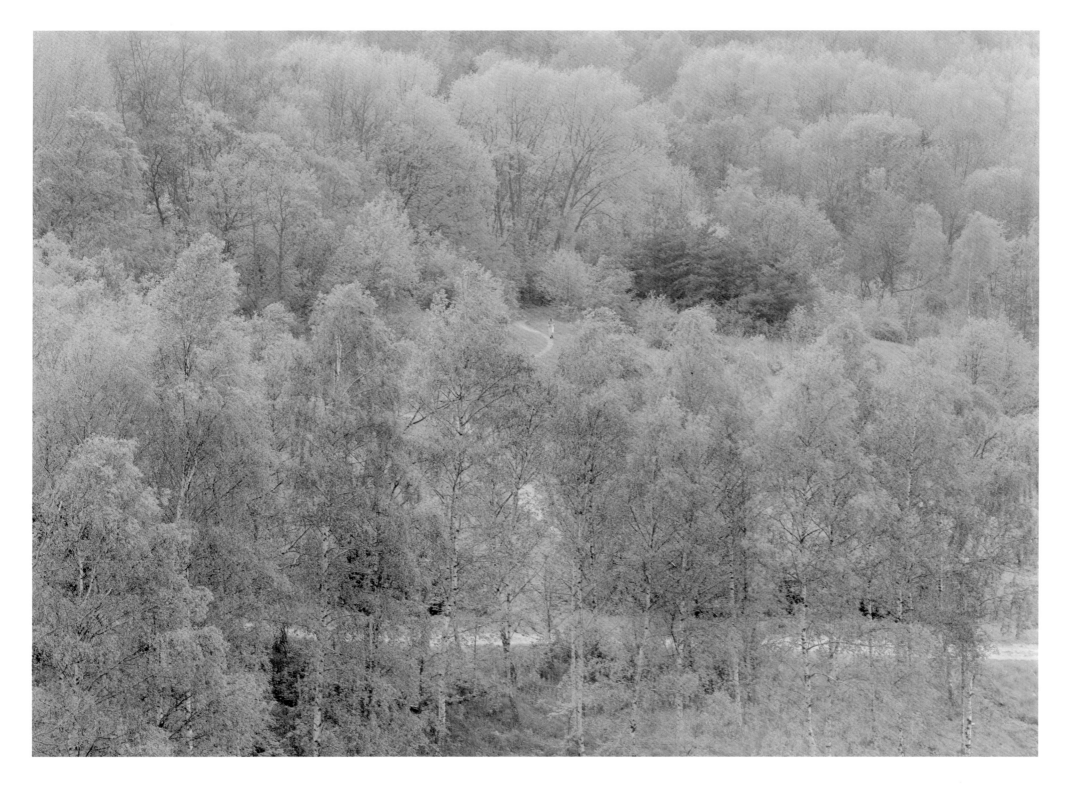

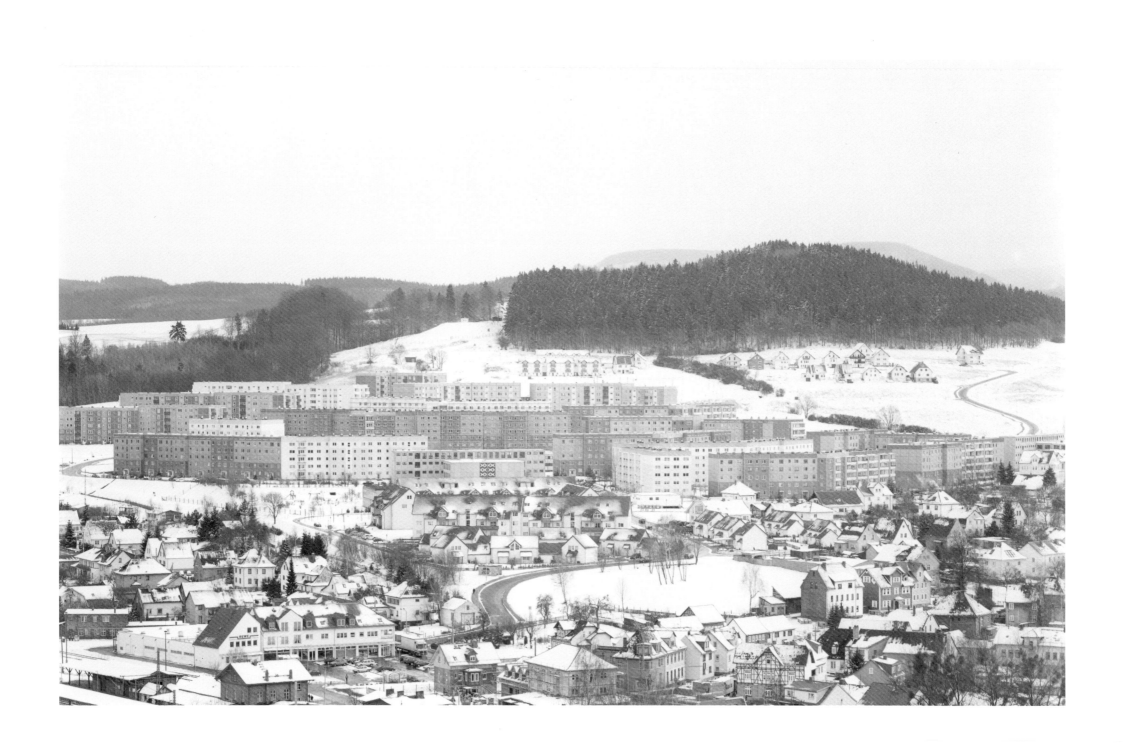

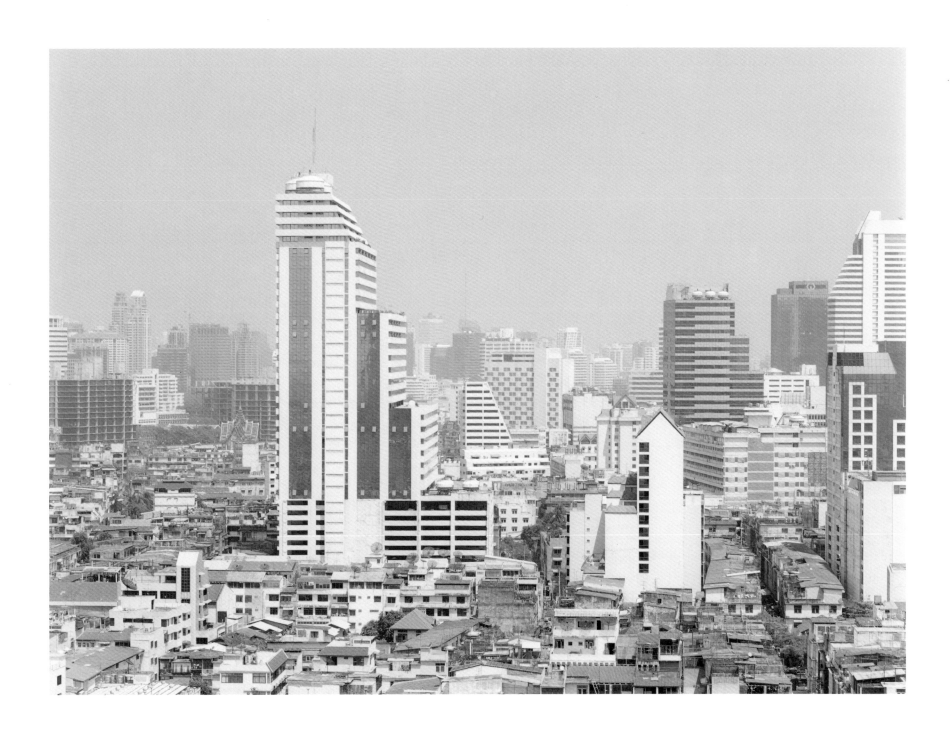

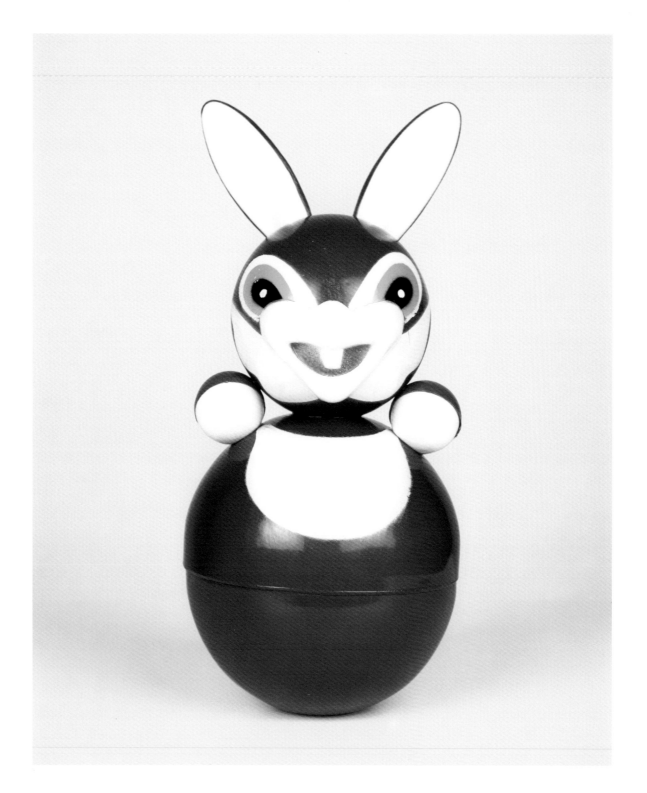

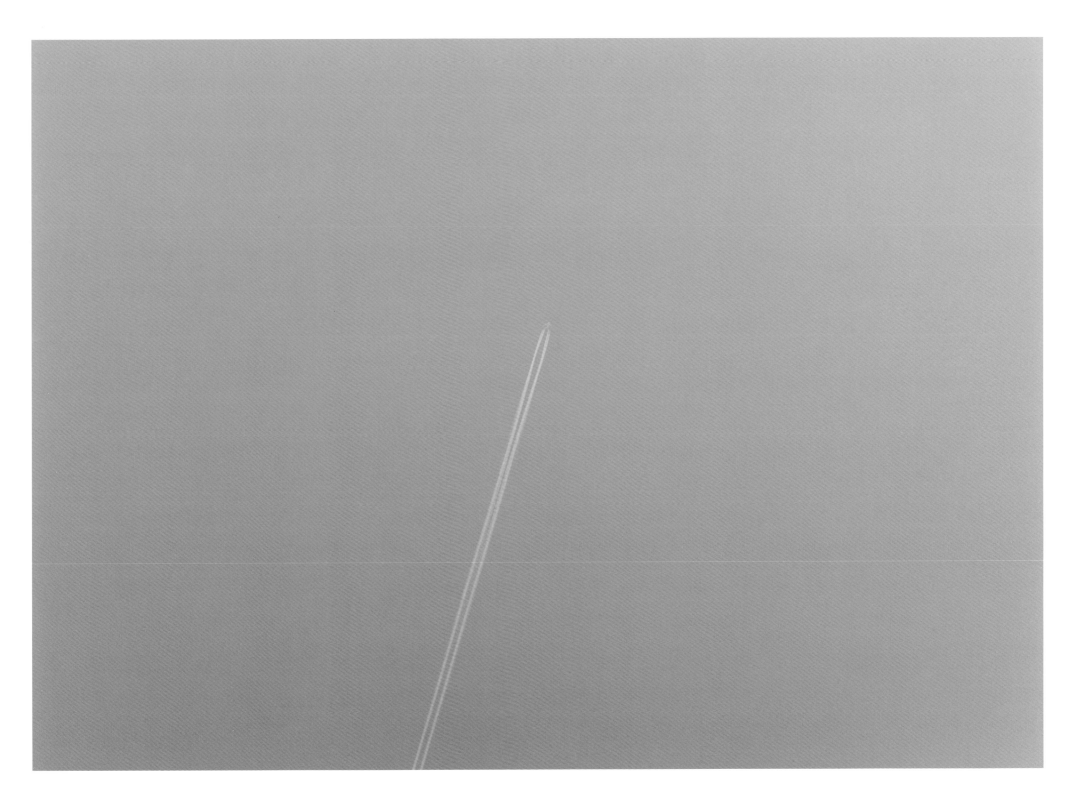

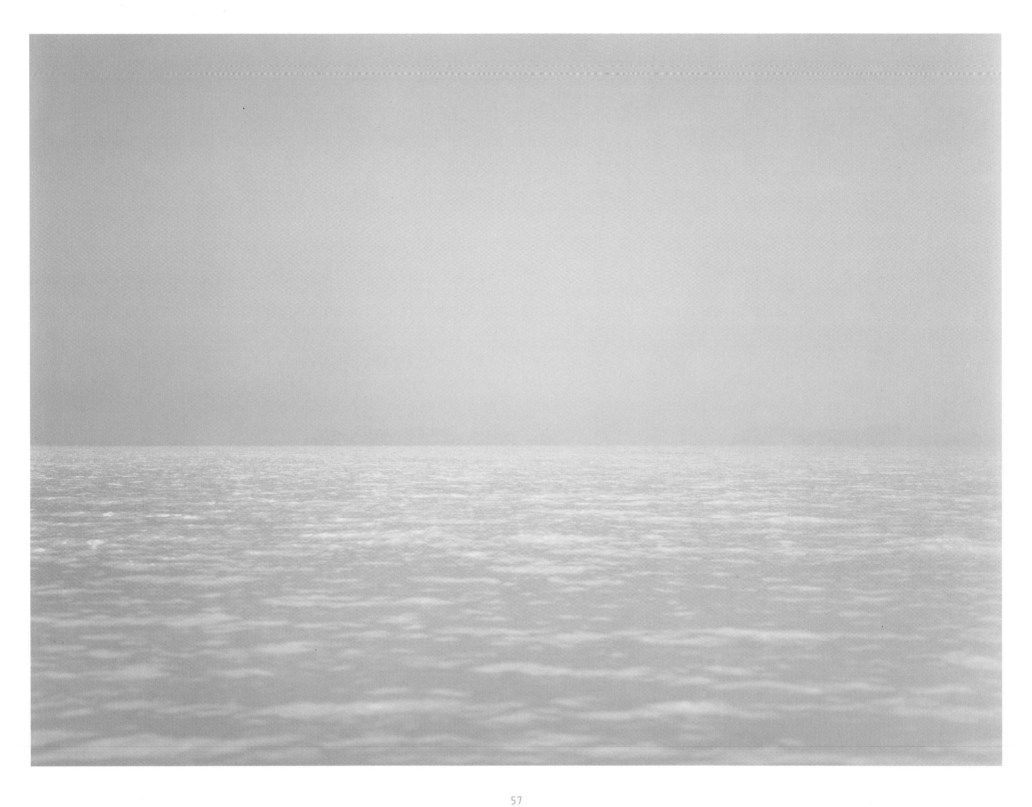

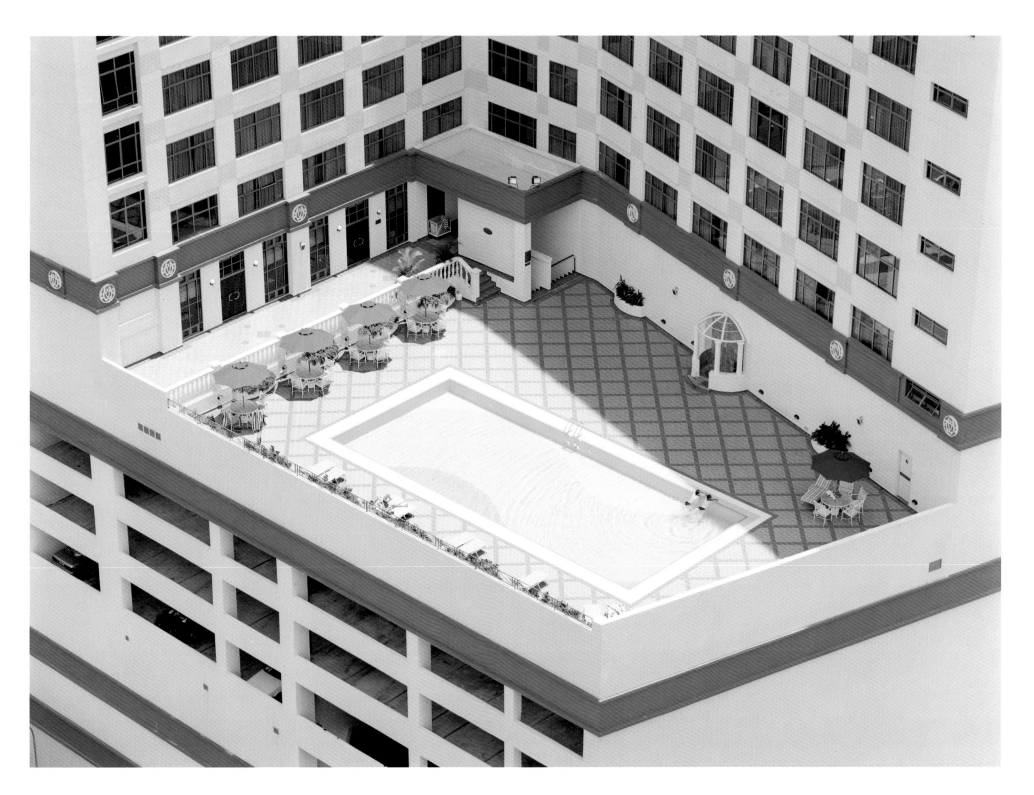

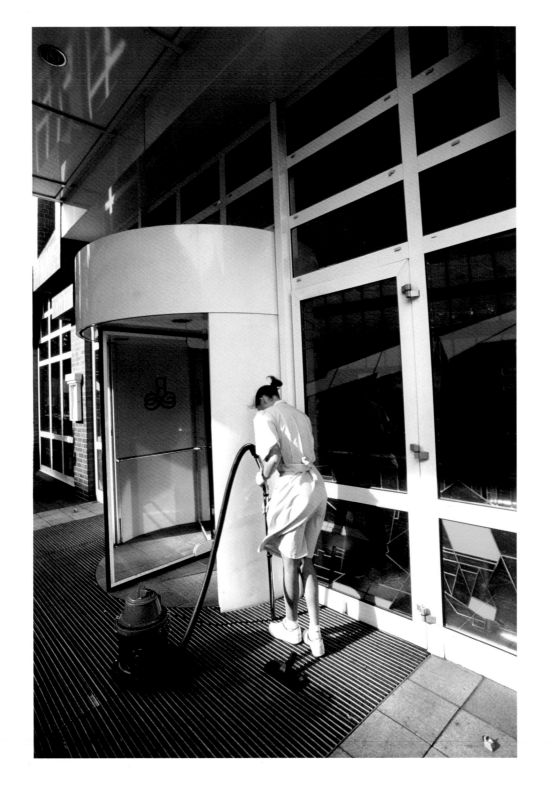

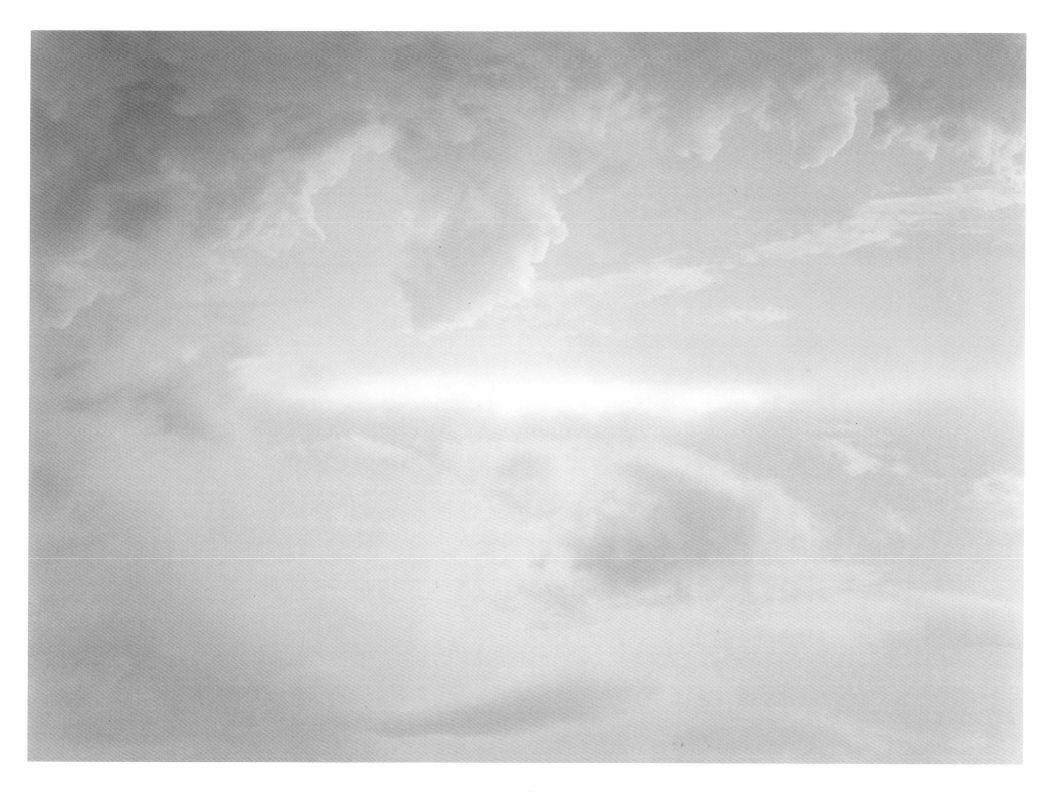

Plates

I would like to thank..... in alphabetical order... christoph dorn, peter grosshauer, butter, beck's, francis bacon, arizona dream, mamiya, anne ebner, blauer engel, helena hanel, albert ebert, ina fee, susa pop, frankie goes to hollywood, nadja bähr, ina brandi, the sea and cake, club waldesruh, dj doch, christoh kopac, tuborg, summer, luba luft, naked lunch, mouse on mars, irving penn, samuel beckett, ankica marjanovic, dolls, desire, smugglers life, tim fischer, nora peters, helga bilitewski, niggemeyer, nikon, private eye, alexander sies, nina höke, hollywood, home, haruki murakami, luciforas, lars von trier, peter jungmann, orson welles, iggy pop, hannah wilke, lars kruse, peter ulrich hein, my parents, sister, family, fassbinder, fogal, weather report, hotels, sudden death, sarah young, britta leyde, spring, zum hecht, jimi hendrix, massive attack, nattawee, buddha, to roccoco rot, starlight, flashlight, flowers, jill bach, mr. morgens

Published by Kruse Verlag, Hamburg, Germany. Design by Artillery, Hamburg, Scans and reproduction by Reproduktion Onnen & Klein, Hamburg. Printed by Druckerei Brillant Offset, Hamburg. Text and photographs copyright © 2000 Frank Darius, copyright © 2000 Kruse Verlag. No part of this book may be reproduced without the written permission of the publisher. Kruse Verlag GmbH, Kampstraße 11, 20357 Hamburg, Germany. Telefone: +49 40 4328246-0. Facsimile: +49 40 4328246-12. E-mail: info@KrusePublishers.com Internet: www.KrusePublishers.com Distribution in North, South, Central America, Asia, Australia, and Africa by D.A.P./Distributed Art Publishers, 155 Sixth Avenue, 2nd floor, New York, N.Y. 10013. Telefone: +1 212 6271999. Facsimile: +1 212 6279484. Distribution in Europe, Asia, Australia, and Africa by IDEA Books, Nieuwe Herengracht 11, 1011 RK Amsterdam, Netherlands. Facsimile: +31 20 6209299. E-Mail: idea@ideabooks.nl Distribution in Germany, Austria, and Switzerland by Kruse Verlag. First Kruse Verlag edition, 2000. Printed in Germany. ISBN 3-934923-03-8.